MULTIPLE MEANINGS

THE WRITTEN WORD IN JAPAN—PAST, PRESENT, AND FUTURE

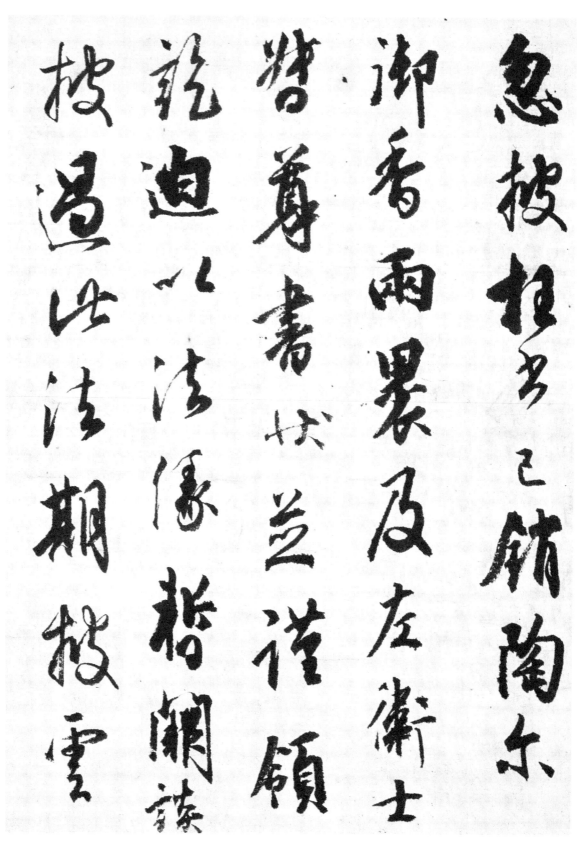

*These characters were written in the ninth century
by Kūkai, the "saint" of Japanese calligraphy.*

MULTIPLE MEANINGS

THE WRITTEN WORD IN JAPAN — PAST, PRESENT, AND FUTURE

*A Selection of Papers on Japanese Language and Culture and Their Translation
Presented at the Library of Congress*

EDITED BY J. THOMAS RIMER

Asian Division

The Center for the Book

LIBRARY OF CONGRESS WASHINGTON 1986

This publication has been partially funded by
the Yomiuri Shimbun of Tokyo.

The art work reproduced for the chapter openings
is from **Kamon daizukan**
(Illustrated Book of Family Crests)
by Niwa Motoji (Tokyo: Akita Shobō, 1971).

A NOTE TO THE READER: Japanese names have been
cited in the Japanese fashion (family name first,
personal name second; e.g., Aoyama San'u), except
in the case of those writers or scholars who work
professionally in the United States and whose
names normally appear in print with the family
name following the personal name (e.g., Kazuo
Sato).

Library of Congress Cataloging-in-Publication Data

Main entry under title:

Multiple meanings.

 Papers from two symposia sponsored by the Center
for the Book and the Asian Division of the Library of Congress.
 Supt. of Docs. no.: LC 17.2:M91
 1. Japanese language — Congresses. 2. Japanese
literature — Translations into foreign languages —
Congresses. 3. Calligraphy, Japanese — Congresses.
I. Rimer, J. Thomas. II. Center for the Book.
III. Library of Congress. Asian Division.
PL503.M84 1986 495.6 85-600365
ISBN 0-8444-0523-X

For sale by the Superintendent of Documents,
U.S. Government Printing Office,
Washington, D.C. 20402

CONTENTS

FOREWORD

 MULTIPLE MEANINGS is a selection of papers presented at two Library of Congress symposia sponsored by the Center for the Book in the Library of Congress and the Library's Asian Division. The first meeting, "Japanese Literature in Translation," was held in 1979. Focusing on the translation of Japanese works into English, it brought together translators, scholars, publishers, linguists, and editors to assess the state of the art and identify special needs. The chairman of the panel discussion on translating contemporary poetry was the editor of this volume, J. Thomas Rimer, then chairman of the Department of Chinese and Japanese at Washington University in St. Louis and today the Chief of the Library's Asian Division. Dr. Rimer took the lead in organizing the second symposium, "Calligraphy and the Japanese Word," which was held in 1984 in conjunction with the opening of a major exhibition — "Words in Motion" — in the Great Hall of the Library of Congress. Funded by the Yomiuri Shimbun, the exhibition combined historical examples of calligraphy from the Library's collections with striking works by Japan's outstanding living calligraphers. The symposium complemented the exhibition by bringing together scholars and calligraphers to discuss how the Japanese language, as illustrated by the art of calligraphy, serves as an example of the way a writing system can both incorporate and reflect the culture it represents. The meeting concluded with calligraphy demonstrations by two eminent Japanese artists.

Technology and the future were represented in the "Words in Motion" exhibition and in the symposium discussions by the Research Libraries Group's CJK (Chinese, Japanese, Korean) system, a cooperative cataloging venture that enables libraries, for the first time, to create machine-readable cataloging records that contain Chinese, Japanese and Korean characters. A six-minute film about the CJK system was made at the Library of Congress for the exhibition and was also viewed and discussed during the symposium. Produced by Washington filmmaker Peter Vogt and funded by the Research Libraries Group and the Library's Processing Services Department, the film is titled *A Tradition Transformed: The CJK Project at the Library of Congress.*

The relationship between traditional forms of the written word and new technologies is one of the major concerns of the Center for the Book, which was established by law in 1977 to promote reading and the study of books and the written word — past, present, and future. In addition to the "Words in Motion" project, in 1984 this concern was also reflected by the publication of *Books in Our Future,* a one-year study authorized by Congress and carried out under the auspices of the Center for the Book. The CJK study was cited in *Books in Our Future* as an outstanding example of the way the computer can complement and indeed extend the uses of the traditional book.

In addition to hosting symposia, the Center for the Book encourages the interdisciplinary study of books in society through projects, publications, exhibitions, and lectures. Most of its projects naturally focus on the rich collections of the Library of Congress, collections that reflect the importance of books and writing in all cultures.

A cooperative endeavor between government and the private sector, the Center for the Book relies on private contributions from individuals, corporations, and foundations to carry out its program. This volume and the two symposia on which it is based were dependent on such contributions, for which we are grateful. The Center wishes to thank Japan Today for its support of the 1979 symposium, the Research Libraries Group for its help in financing and advising on the CJK film, and the Yomiuri Shimbun for sharing the cost of the 1984 meeting with the Center and for assistance in publishing this book.

The Center also acknowledges the efforts of J. Thomas Rimer, whose many skills and enthusiasm for the entire project made this volume possible, and would like to thank Iris Newsom for her many helpful editorial suggestions.

The translation of Japanese language, art and culture and their influence on the western world are fascinating topics. It is a pleasure to share these Library of Congress presentations and part of a remarkable Library of Congress exhibition with a wide audience.

John Y. Cole
Executive Director
The Center for the Book

INTRODUCTION

 To insist on the crucial importance, indeed the centrality, of language as a means of transmitting culture around the world may seem only to repeat an obvious commonplace. Yet in the West the investigation of how languages function in all their diversity has constituted an important field of intellectual endeavor since the rise of philology as a serious academic inquiry after the Renaissance. In Japan as well, the search for an understanding of the functions of language in determining and defining cultural, literary, and philosophical self-awareness has been a subject of inquiry since the introduction of classical Chinese in the early centuries, culminating in the work of the great critic Motoori Norinaga (1730–1801), whose research into the differences between Chinese and Japanese language and culture helped define a Japanese sense of national identity. In Japan today the study of language and its functions keeps fully abreast of similar research in the United States and Europe. Thus, the importance of language and its functions would seem to be acknowledged around the world.

In the case of Japan, the matrix of written linguistic materials that makes up the potential means for written expression is much richer than any available for the European languages. Its various elements, however, can appear bafflingly complex to a native speaker of English. One simple example, the case of words borrowed from another language, can serve as an illustration. English speakers try to use, and to spell properly, bits of Latin, French, and German in their domesticated English forms. Since the nineteenth century, many words from all of these languages have been imported into the Japanese language as well. In addition, since the fifth century, written Japanese has included a great many Chinese characters. A modern sentence may thus show these characters in both older and postwar simplified forms, as well as other words written in one or the other of two possible systems of phonetic syllabaries; foreign words are, as often as not, written in their own appropriate alphabets. It seems just indeed that the French literary critic and semiotician Ronald Barthes called his 1970 study of Japan *L'Empire des signes (Empire of Signs)*, so rich did the range of visual communication in the Japanese language seem to him.

The history of the written word in Japan began, in fact, with the importation, probably in the fourth or fifth century, of what is now termed classical written Chinese. At that time, the Japanese had no developed writing system of their own. By the time they had come to create, through the experience of learning to write an alien language, their own phonetic system of written symbols, so many Chinese concepts and words had been absorbed into their own language that the written Chinese characters became a permanent and central part of the Japanese written language. Perhaps a very general analogy might be made to the circumstances in which French found its way into Old English during the Norman Conquest, a process that brought about an alteration of the English language; yet even so, in this case, the two writing systems were largely similar. Chinese, on the other hand, was based on concepts of sound and written signs so different from any elements present in the Japanese language that by the time the Japanese had managed to domesticate Chinese for their purposes, the Japanese language had to be profoundly wrenched about and adapted so as to incorporate this powerful flow of continental linguistic culture. Eventually an accommodation was achieved, and a sinified Japanese became the language in normal use. In addition, those in court circles and the Buddhist church continued their own study of the Chinese language itself. Written Chinese thus came to function in the Heian period and in medieval Japan somewhat in the same manner as did Latin in medieval Europe: it was an international mode of communication understood by all men of superior education and culture. Chinese continued to provide that sense of universal culture almost until the end of the nineteenth century, when it was replaced by French, German, and especially English. It is through the means of these Western languages that Japan entered into relations with the modern Western world, and indeed the Japanese written language still remains a formidable barrier, one so subtle, complex, and difficult to learn that normal modern means of communication — copying, typing, printing, and translation — have continued until quite recently to present stubborn challenges. There are many special problems and opportunities involved in attempting to surmount these barriers. Some of them are discussed in personal and engaging terms in the essays that follow.

One special opportunity provided to Japan by this importation of Chinese characters involved the possibility of the development of language as a visual art to an extent almost impossible to imagine with any Western alphabet. The ability to exploit the shapes of Chinese characters (as well as the Japanese phonetic syllabary) in a variety of artistic ways helped make the visual poetry of calligraphy an accomplishment of the highest order, fully a sister art to poetry and painting. In the tradition of calligraphy as an art, words may retain their lexical meanings but can in addition express an emotion or an idea, as well as indicate something about the character of the calligrapher who wrote the text. Few would care to posit any similar claim for the potentials of Western handwriting.

Written Japanese, classical or modern, handwritten or printed, also poses special problems for the translator, who must make as specific and clear as possible original texts written in a language that has traditionally enjoyed full use of the richness of the literary possibilities inherent in the presence of so many homonyms and an ambiguous syntax, both seen as literary virtues that helped create one of the great poetic traditions of the world. In this context translation may well amount to shrinkage; yet inevitably more and more efforts are being made in this generation to make the fruits of the Japanese literary, historical, and scientific sensibilities available around the world. In this regard, the most sophisticated of modern electronic technologies have become increasingly available to help bridge such gaps. Computer typesetting, new printing devices, even translation machines are making the manipulation and reproduction of this ancient language more and more consonant with the techniques developed for European languages, where the problems are considerably simpler to resolve. Future communications into and out of Japanese may soon become as viable as present exchanges between French, English, or Spanish.

As Hisao Matsumoto states in Appendix 1, the Japanese collections of the Library of Congress are among the richest in the world, and the presence of many scholars both from here and abroad has permitted a number of occasions in past years for useful scholarly exchange. Contributions from two such occasions are included here, one on contemporary calligraphy and the future of communication, and the other on the art of translation. The range of topics as recorded here was wide, and the diverse interests and various personalities of the contributors made the discussions mutually stimulating, often provocative. Despite the varied scope of concerns expressed, however, the essays of all the contributors address the realities of the Japanese language. Read together, they provide an imaginative view of our contemporary worldwide concern for language as a resource for discovering mutualities of meaning.

J. Thomas Rimer
Chief
Asian Division
1983-1986

MEANING AS ART

Papers from the Symposium "Calligraphy and the Japanese Word"

 The Library of Congress, in conjunction with the Yomiuri Shimbun, sponsored an exhibition entitled "Words in Motion: Modern Japanese Calligraphy" in the Great Hall of the Library's Jefferson Building from June 15 to September 15, 1984. A selection of the work of thirteen distinguished living calligraphers was shown. The exhibition provided the first occasion for postwar accomplishments in this important art form to be seen in the United States. Also included in the exhibition was a selection of important items concerning traditional calligraphy, taken from the collections of the Asian Division of the Library. In order to commemorate the exhibition and the artistic importance of the works of art on display a catalog of the complete exhibition was prepared and published. (Copies are still available at $17.00 from the Library of Congress Information Office, Box A, Washington, D.C., 20540.)

A symposium on calligraphy was also held at the Library on June 15, following the official opening of the exhibition. In addition to a number of discussions and demonstrations, several papers were presented on that occasion that described various aspects of calligraphy and its importance in Japanese culture. The ways in which meaning and art combine to reinforce each other provided the intellectual framework for these various contributions.

THE HISTORICAL DIMENSION

TRANSMISSION AND TRANSFORMATION
Chinese Calligraphy and Japanese Calligraphy
by Yoshiaki Shimizu

Yoshiaki Shimizu, Professor of Japanese Art at Princeton University, has had a long personal association with the art of calligraphy, having studied with Kamijō Shinzan, one of the calligraphers represented in the exhibition. He prepared a number of important national exhibitions during his tenure as Curator of Japanese Art at the Freer Gallery of the Smithsonian Institution from 1979 to 1984, has written both on calligraphy and on Japanese ink painting, and is the author, with John M. Rosenfield, of the catalog for the 1984 exhibition "Masters of Japanese Calligraphy," held at the Japan House and Asia Society Galleries in New York City.

In this essay, Mr. Shimizu observes the means by which the Japanese were able to import a cultural system different from their own, acclimatize themselves to it while maintaining their identity, then add their own creative genius to produce a new synthesis of artistic possibilities. Mr. Shimizu's general cultural model as described here in terms of calligraphy can help provide useful insight into many of the means by which Japanese society has come to function so successfully.

 The Library of Congress exhibition of works by the modern master calligraphers of Japan could not have been better timed in terms of the recent growing interest in this country in Chinese and Japanese calligraphy which is shared by the specialists and general public alike. As luck would have it, the opening of this exhibition may be seen as a preamble to another exhibition, "Masters of Japanese Calligraphy," — one that includes more comprehensive works from all periods in Japanese history — organized by the Asia Society and the Japan House Galleries in New York City, which will open in October, 1984.

The writing tradition in Japan is an offshoot of the Chinese tradition, which Japan inherited from the moment Chinese characters were introduced to the island nation around the end of the fifth century A.D. Because of the continuous influences from the continental culture of China that came to Japan, it should come as no surprise that among the thirteen calligraphers represented in this exhibition, the majority of their *ouvre* shows an overriding adherence in format, textual sources, and writing style to the Chinese tradition. Though generally traceable to Chinese precedents, the works displayed in this exhibition also illustrate impressive innovations in the vocabularies of brush work employed, some of which are totally alien to the Chinese view of calligraphy. In this Japanese metamorphosis there is a freedom from the orthodoxy of the Chinese canon of calligraphy that can only be explained by reflecting on some of Japan's artistic responses to China throughout her history. It is the phenomenon of Japan's responses to the Chinese calligraphy tradition which I would like to address, perhaps somewhat ambitiously, on this occasion.

The transmission of the arts of one culture to another, resulting in their adaptation and transformation, in part or in whole, presupposes several conditions, of which these four are perhaps most important:

1. People must travel from one civilization to another.
2. The people carry with them artistic products and knowledge about them.
3. The receiving culture has a population prepared to accommodate these imports and enough knowledge to emulate and reflect upon them.
4. Once transmitted, the imported arts are examined for adaptation; in the course of the examinations and trials, a considerable amount of

5

transformation, interpretation, and even mutation occur. These processes may be immediate or may take a considerable period of time. A cultural transmission of this sort anticipates many changes that do take place over time on the part of the recipient, and indeed those changes that evolve may even include a violation of the original forms and principles that could result in the appearance of new products that are no longer reexportable to the place of their origins. That transformation is at once a result of an internalization of the creative process on the part of the recipient and a deviation from the original form or, to put it another way, a "creative misunderstanding." The history of the transmission of Chinese calligraphy to Japan and its transformation illustrates, to a remarkable degree, a phenomenon of creativity based upon an early violation of Chinese tradition, which developed into an astounding artistic tradition in its own terms.

Initial Transmission

In A.D. 57, according to a Chinese source, a gold seal was given to a Japanese envoy. A gold seal with an inscription in Seal script was discovered in 1784 in a field in northwestern Kyūshū. Now designated as a national treasure, it is commonly accepted as a genuine Han seal. At that time, however, the Japanese had not developed a writing system of their own.

By the time Japan is believed to have received the gold Han seal, China's system of scripts was already a millenium old. By Han times, all the script types that were to be written by the Chinese for the next two millenia had been formulated; and as is seen in the writing done with a brush on a bamboo slip datable to 44 B.C. from Chü-yen in northwest China, the writing system already had artistic potential that would endure throughout the rest of China's history. As an aesthetic accomplishment, the art of writing was traditionally considered second only to poetry and followed by its sister discipline, painting. Ever since artistic possibilities were found in the flexible use of the brush and in the structuring of characters, various types of writing provided a repertoire for distinguished calligraphers. During the period from the fourth to the sixth centuries, the Chinese art of writing emerged as a self-conscious activity of emulation directed toward artistic personalities, as was clear in the work of such men as Wang Hsi-chih (307–365) and Wang Hsien-chih. From the moment these calligraphers began to be seen as models to be followed, the art of calligraphy became a tradition of emulation and celebration of the great personalities, and a critical knowledge of calligraphy became a part of that tradition.

Japan, as well as Korea, inherited its writing system from China. Of these two neighboring countries, Korea came under the influence of China's writing system much earlier than Japan. With the establishment of Chinese colonies in the Korean peninsula in the second century B.C., Chinese script types began to be widely used in Korea, as is evident in the works discovered at Lo Lang. Throughout the Silla, Paekche, and Koguryo periods, sinification of Korea was thorough. Probably Korea's geographical closeness to China prevented her from developing her own writing system in spite of the linguistic differences. Not until the midfifteenth century did the Koreans invent their own alphabet system — Han'gŭl.

Japan's introduction to Chinese characters, with all their typological varieties, took place much later than Korea's. It is generally agreed that the sixth century A.D. is the earliest period the Japanese were using Chinese script types. This is evident from the Chinese characters in relief on an excavated mirror from Wakayama, datable to A.D. 503. In the second border of this bronze mirror is an inscription in relief, forty-eight characters of the Clerical-Standard script type. The somewhat crude characters are unique not because of the preartistic form of each character but in the use of Chinese characters as loan characters to render Japanese sounds for proper nouns. The fifteenth to eighteenth characters are read:

o shi sa ka

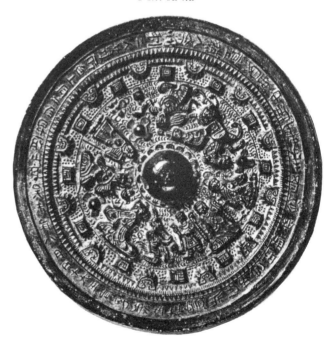

This bronze mirror dates from A.D. 503 and was excavated in Wakayama. The detail shows an inscription in relief in Chinese characters of the Clerical-Standard script style. From Kokuhō (Tokyo: Mainichi Shimbunsha, 1963).

which designates the name of a palace. Such usage indicates that in the early sixth century Japanese writing practice included the use of such borrowed characters to represent Japanese sounds. This and other pieces of evidence show that the Japanese borrowed Chinese characters for their phonetic sounds, for which there had been no Japanese counterparts. This represents the first stage of the Japanese transformation of the integrated function of Chinese characters. Through this process, the threefold function of each Chinese character—the structure, the meaning, and the sound—began to disintegrate in Japan. The Chinese characters which had meanings in themselves were transformed into the Japanese phonetic systems and used independently to function as the written equivalent of Japanese sounds. As a historical process, the Japanese adaptation of the already existing written graphs to represent their own words in written forms may be compared, although in a different context, to the Chinese practice of using their characters as phonetic signs to represent foreign words. Taken as a phenomenon of an alteration in written words of one culture by another, this adaptation represents an instance of a violation of the original system by adding an additional function. The imported written characters, therefore, assumed a double function in Japan at this early stage. On the one hand, the original Chinese practice was preserved by retaining the system as a written language of China comprehensible to the literate population; on the

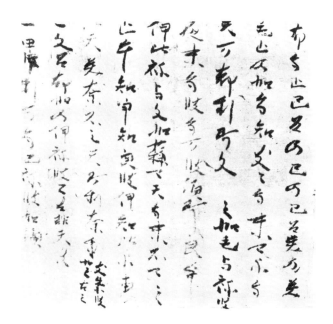

An ink on paper document from Shōsō-in, Nara, circa A.D. 762, shows Semicursive script Chinese characters being used as phonetic signs for Japanese. From Shōdō zenshū *(Tokyo: Heibonsha, 1954).*

other hand, the Chinese characters, used as phonetic signs, began to create a new system of sounds appropriate for transcribing the Japanese language in a manner comprehensible only to the Japanese.

A document in the Shōsō-in Imperial Repository in the ancient capital of Nara, presumed to be an informal letter, datable to no later than 762, demonstrates how, in representing the Japanese language in written form, Chinese characters were used as loan characters. This time the text is written by brush and on paper and is in Semicursive script. The first line begins:

fu ta to ko ro no ko no ko ro mi no mi

All in all, this document tells us that by the mid-eighth century the Japanese had already developed a phonetic system. In modern Chinese, those sounds should be rendered as:

pu to chih chi lü nai chi nai chi lü mei nai mei

Some sounds in Chinese are approximated by Japanese counterparts. The differences, however, may be in the modern and ancient Chinese sounds themselves; on the other hand, it may be argued, as some specialists have done, that the sounds the Japanese adopted were those enunciated by the Koreans, or the literate Koreans from Paekche residing in Japan, whose leadership in guiding the Japanese in building their early state of Yamato has

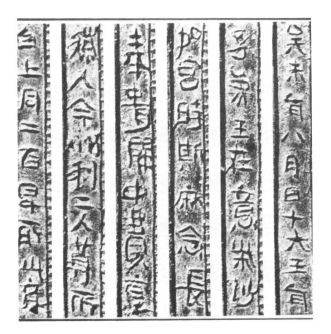

been a matter of record. In any case, it is this phonetic system which is used extensively in the first great anthology of Japanese poems, the *Manyōshū*. The term *manyō-gana* is used to describe it.

The bronze mirror inscription and the Shōsō-in document are similar in that they show Chinese characters as Japanese phonetic signs. These characters, when seen as forms, are different in each. The mirror inscription uses the Chinese characters as loan characters without violating the forms of individual characters, while the Shōsō-in document in some instances uses them with a change in structure. The Shōsō-in document is written in Semicursive script. The structural simplification due to the accelerated movement of the brush, in some instances, differs from the normal change in Chinese writing practice. Take the third character *to* or *chih*, which means "to cease." In the Chinese Cursive script type writing, it resembles those characters on the right-hand column of the chart shown here. The Japanese version to the lower left reveals a structural change based upon a different stroke order. This structural transformation anticipates the further distortion of the structure that took place during the following Heian period, resulting in the *sō-gana* or Cursive syllabary system, which came to full flower in the tenth and eleventh centuries.

During the Heian period, the Japanese Cursive *sō-gana* was developed. That system not only shows structural variation in each character, but also reveals that there was more than one character per sound. The inflated variety of such Cursive script was in wide usage until the Meiji period, when one phonetic sign per sound was chosen, totaling fifty-one.

The Cursive script system ultimately enabled the Japanese to develop their unique calligraphic traditions in the Heian period. The most typical and aesthetically new calligraphic style that apeared using the *sō-gana* phonetic syllabary system is *waka* — the transcription of the indigenous genre of poetry— best illustrated by the *Kokinshū* manuscript of the tenth century.

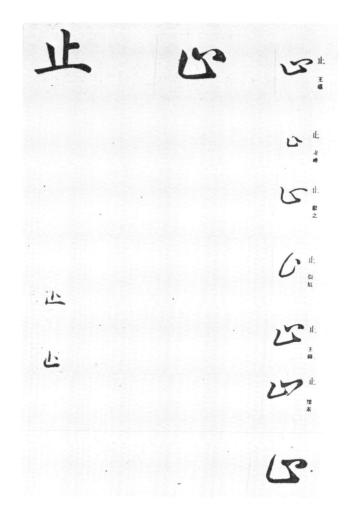

The character to *(to cease) in Chinese and Japanese.*

Signs into Art

The Nara period (eighth century) writing tradition developed within the educationally homogeneous group of men and women who lived close to the court and the official Buddhist institutions, where the practice of writing official documents and transcribing Buddhist sutras and Chinese poems or prose was part of their learning. It is safe to assume that the general level of literacy among the best-educated persons outside the aristocracy was probably not too different from that of those at court, as is clear from the poems exchanged in the *Manyōshū* anthology.

In the following Heian period, particularly from the tenth century onward, the situation changed drastically. The male members of society began to dominate the major fields of Chinese study, and this probably caused the gradual withdrawal of women from public participation in Chinese learning. For instance, Lady Murasaki tells us in her diary that she gave reading lessons on the literary works of Po Chü-i to Princess Shōshi in secret. Once when she was caught by another lady-in-waiting while opening a Chinese book given to her by her departed husband, she was told that such Chinese books were the very cause of her misfortune. Such references may indicate that a taboo gradually began to set in, separating women from Chinese learning and education in general, which undoubtedly included writing in Chinese. If women began to be discouraged from using Chinese calligraphy and Chinese script types to write Chinese and compose poems, what writing did they practice, and what scripts did they use more frequently? The only acceptable scripts then must have been *kana* or the transformed *kana* syllabaries already in existence.

The initial structural changes that had already occurred in the Japanese Cursive scripts went further as they became the most frequently used medium of writing. The appeal of *kana* was in its simplicity compared with the tedium of writing formidable block or "square" characters associated with formal documents and Chinese literature, which by then had begun to appear remote. The Cursive writing developed not in the traditional genre of Chinese literature — Buddhist sutras or Chinese-style poems — but in private letters, messages, and *waka*. Thus these scripts developed an atmosphere of intimacy that began to be called suggestively *onna-de* or "female hand." During the Heian period *onna-de* designated the script type and writing habits of

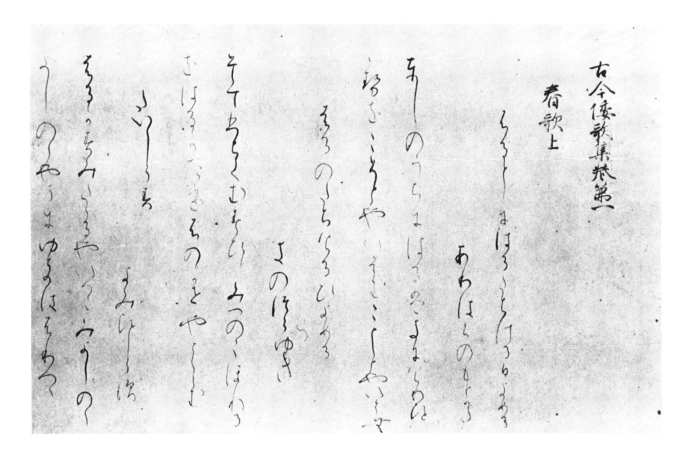

A transcription of waka *poems from the tenth-century* Kokinshū *anthology done in ink on mica-coated paper. From* Shōdō zenshū *(Tokyo: Heibonsha, 1955).*

9

kana. The establishment of these Cursive scripts can be assumed to have taken at least two centuries.

From the time that simplification of characters began among the Japanese syllabaries, this new set of scripts showed artistic potential: loops, links, and curves resulting from structural simplification became the essential aesthetic properties of Cursive writing as an art form. In brush technique these scripts possessed some elements of Chinese Cursive writing, but the structure within a single script is far simpler than in the Chinese counterparts. The aesthetic effect was further pursued by linking scripts, sometimes without even a single break in line, and the writing was done with an extremely finely pointed brush, of which only one-fifth or one-sixth of the total hair length was dipped in ink. It is this style of writing which characterizes some eighteen fragments of a letter datable to A.D. 966 which was discovered at Ishiyamadera on the back of a Buddhist prayer. Here we can see that the typical stylistic features of linked Cursive script (*Renmentai*, meaning "linked silk thread mode") are all present in this midtenth-century writing: variation in the size of characters, as well as loops and curves done with the maximum use of the center tip of the fine brush.

Although the Ishiyamadera fragments are simple letters by an anonymous calligrapher, the fully artistic refinement of this style had definitely been attained by the early eleventh century, according to tradition, by the aristocratic calligrapher Fujiwara Kōzei or Yukinari (972–1027). This "Kōzei style" of *kana* calligraphy was seen as a supreme model of Japanese cursive writing in the document known as *Kōya-gire* or *Kōya fragment*, sections of a scroll transcribing *waka* from the 905 *Kokinshū* anthology. The calligrapher used a flowing style of *kana* calligraphy to transcribe *waka* poems on mica-coated sheets. This represents the ultimate artistic refinement of the *kana* syllabaries developed by the Japanese. The *kana* calligraphy tradition became the ultimate indigenous mode of writing for the Japanese. It represents what the Japanese term *wayō*, or the Japanese mode of writing, to be distinguished from *karayō*, or the Chinese mode, to which we now turn.

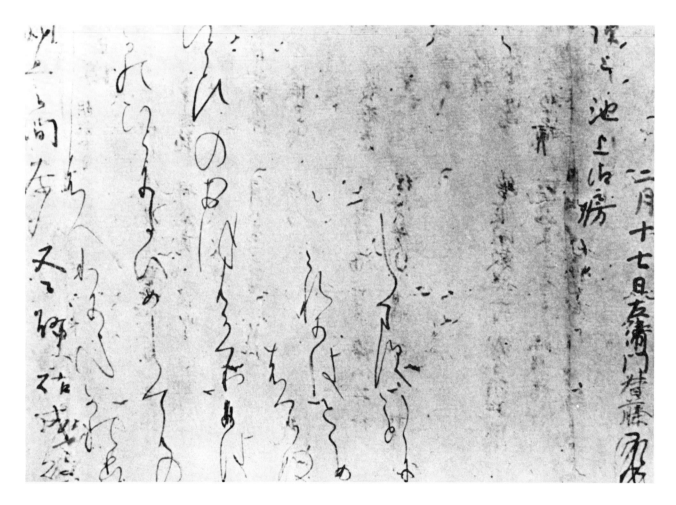

A letter datable to A.D. 966 in linked Cursive script, found at Ishiyamadera. From Shōdō zenshū *(Tokyo: Heibonsha, 1954).*

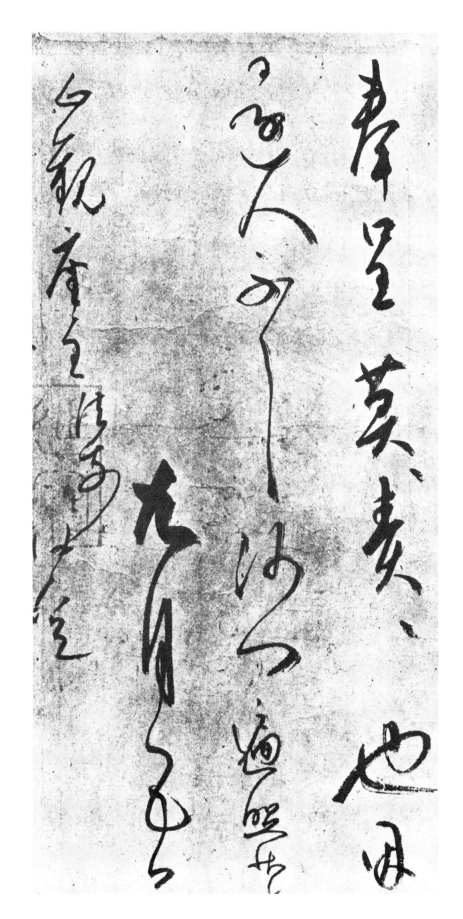

A letter from Kūkai (774-835) to his friend Saicho, in ink on paper. From Shōdō zenshū (Tokyo: Heibonsha, 1960).

11

The Chinese Mode

While the Japanese were developing their native Cursive scripts through the Nara period into the Heian, there was, concurrently, a development of T'ang Chinese calligraphy, which may be best represented by the works of Kūkai, known by his posthumous title of Kōbō Daishi.

As an artistic personality, Kūkai is to the Japanese what Wang Hsi-chih is to the Chinese. His fame rests on his direct contact with the metropolitan culture of early ninth-century China, where he was a visitor. With his return from China in 806, Kūkai's reputation increased not only as an eminent priest of the esoteric school of Buddhism, but as a calligrapher as well. Among works traditionally attributed to him, however, only a handful actually reveal his writing style. Kūkai's works differ from those of his predecessors of the Nara period in that he was able to see T'ang calligraphy at first hand and to understand its history and artistic possibilities. As an artistically conscious calligrapher capable of choosing models to follow or of formulating theories, he was the first in Japan to make the art of writing a creative endeavor. Kūkai articulated many of his thoughts on poetry and calligraphy, based on his learning and experience in China, in his collected works *(Shōryōshū)*, compiled by his follower Shinzei.

The most reliable calligraphy of Kūkai is represented by his letters, three in all, addressed to his friend Saichō, and now in Kyō'ōgokoku-ji in Kyoto. The three letters reveal Kūkai's absorption of contemporary Chinese calligraphy —both the orthodoxy of Wang Hsi-chih and the new style of Yen Chen-ch'ing (709–785). Kūkai's sojourn in China lasted for fourteen months, during which time he is said to have become acquainted with a certain master calligrapher from whom he learned, through oral explanation, the technique of calligraphy. This master calligrapher remains unidentified, but from the existing works of Kūkai, it is certain that Kūkai had eyes like antennae receiving what must have been varied current calligraphic styles in Ch'angan, the capital of China during that period. These letters, composed after his return to Japan, clearly demonstrate Kūkai's mastery of the contemporary style of Chinese calligraphy.

The Chinese style of calligraphy brought to Japan by Kūkai found its roots in Japan just as the Japanese were slowly developing their new *kana* Cursive scripts. The tenth-century Emperor Daigo, who admired Kūkai and bestowed upon this extraordinary priest the posthumous title of Kōbō Diashi, was a calligrapher as well. A unique surviving work of this emperor's calligraphy is a section of a scroll transcribing a Po Chu-i poem, now in the Imperial Household Collection in Tokyo. Executed in the Chinese mode of Cursive style, this work is one of many examples that indicate how far the Japanese followed the Chinese calligraphic traditions in all their stylistic diversity. These Chinese modes, to be distinguished from *wayō*, are known as *karayō*, and represent the very foundation of the Chinese-style calligraphy that continued to survive through Japanese history down to the modern era.

A transcription of a poem by Po Chu-i executed by Emperor Daigo (885-930) in the Chinese mode of Cursive style script. From Shōdō zenshū *(Tokyo: Heibonsha, 1954).*

Development of the *Kana* Calligraphy

By the time the texts of the famous illustrated *Genji monogatari* were transcribed in the early twelfth century, the *kana* calligraphy as an art form was nearly two hundred years old. The dating of this celebrated scroll, in fact, is based upon the style of its *kana* calligraphy. The usual date given — circa 1125 at the latest — is a late one for the development of

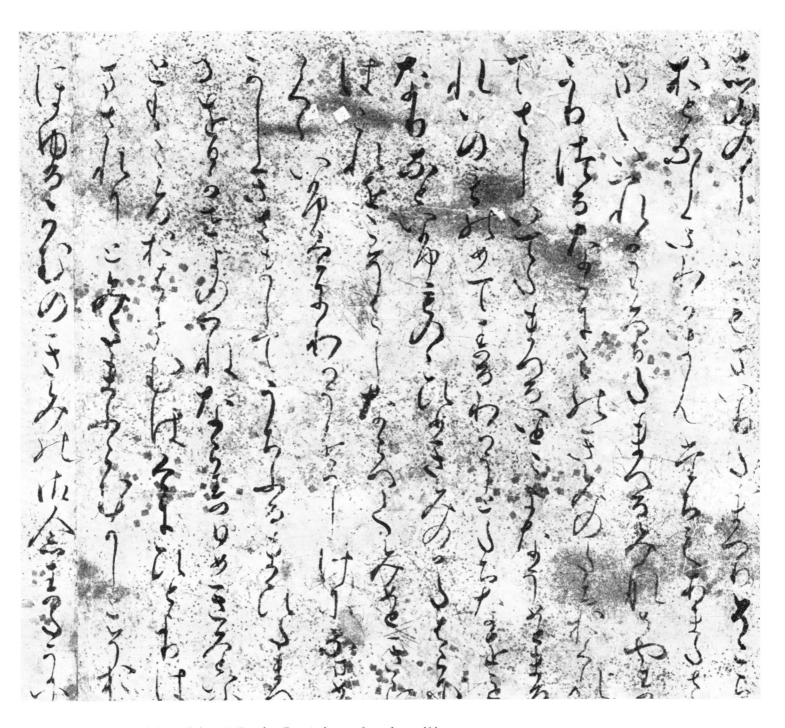

A *transcript of the text of the "Takekawa" (Bamboo River) chapter from the twelfth-century*
Tale of Genji *done in* kana *calligraphy in ink on decorated paper. From* Genji monogatari
emaki *(Tokyo: Kadokawa Shoten, 1958).*

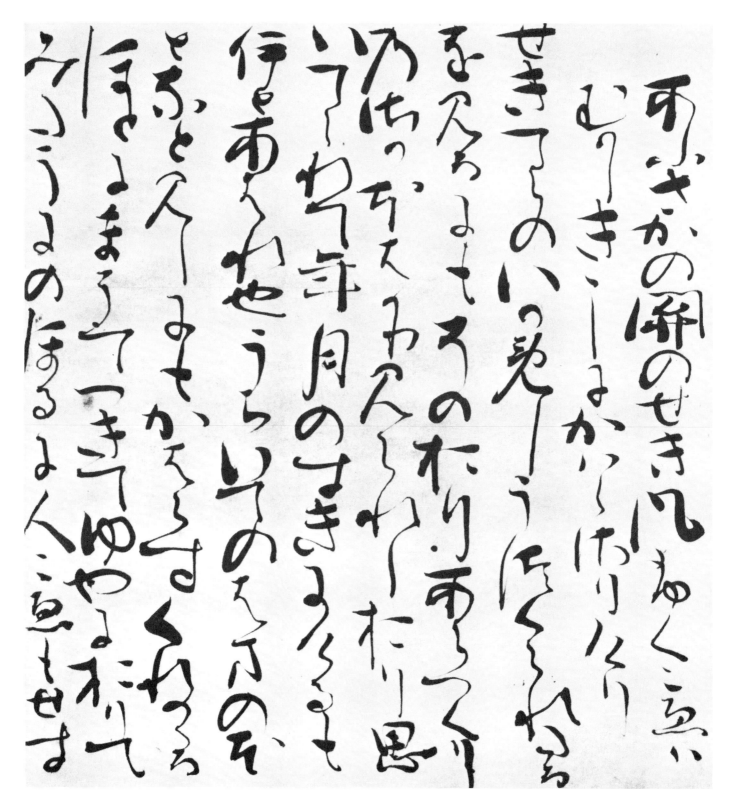

This transcript of the eleventh-century manuscript Sarashina nikki *was written in ink on paper by the great court poet of the Kamkura period, Fujiwara Teika (1162-1241). From* Shōdō zenshū *(Tokyo: Heibonsha, 1960).*

the Heian *kana* calligraphy. If we compare the calligraphy of the Genji scrolls with the *Kōya-gire* attributed to Kōzei, the change in styles of writing that can be observed tells us something of the stylistic shift over time as well. By the early twelfth century the supreme style of eleventh-century *kana* delegated by *Kōya-gire* had been expressively individualized. The style of this illustrated calligraphy which transcribes the "Takekawa" (Bamboo River) chapter reveals a different perception towards *kana*. The contrast between thick and thin forms of *kana* characters imbues the work with nervous energy. A further stylistic diversity of *kana* calligraphy must be assumed.

A transcript of the mideleventh-century manuscript *Sarashina nikki* was written by the great court poet of the Kamakura period, Fujiwara Teika (1162–1241). What we already have seen in the text of the "Takekawa" chapter in the Genji scroll is even more dramatically revealed in this writing: the smooth flow of characters has disappeared. In its place impetuous variations of the extremely thin as well as thick strokes now form a character. The uneven directions of the axis of characters create an uneasy flow of the brush. The push and pull of the brush from the paper creates this peripatetic movement. The space occupied by the characters and surrounding them becomes elastic. In every sense an anti-Kōzei style is established here. Significantly, the Cursive script type of Chinese characters occasionally punctuates the columns.

Although Teika's style did not have a significant following until the Edo period, the stylistic significance of this extraordinary writing is to be understood in two contexts: first, as a reaction to the staleness, so to speak, of the orthodoxy of Kōzei and his followers; and secondly, as a reaction to the emergence of a fresh style of calligraphy gradually finding its way to Japan from Southern Sung China. As to the first, I shall simply mention that the conservative school which followed Kōzei, known as the Seson-ji School, perpetuated the orthodoxy of *kana* for nearly six generations without any significant stylistic change. With the exception of an occasional formulation of treatises on the technique of calligraphy, this school, however prestigious with all its claim to an exalted ancestry, remained stagnant in the thirteenth century. In Japanese calligraphy in the thirteenth through the fourteenth centuries, it was the calligraphy of Sung China that was the most important, a fact that, for a moment, takes us away from the pursuit of *kana* calligraphy.

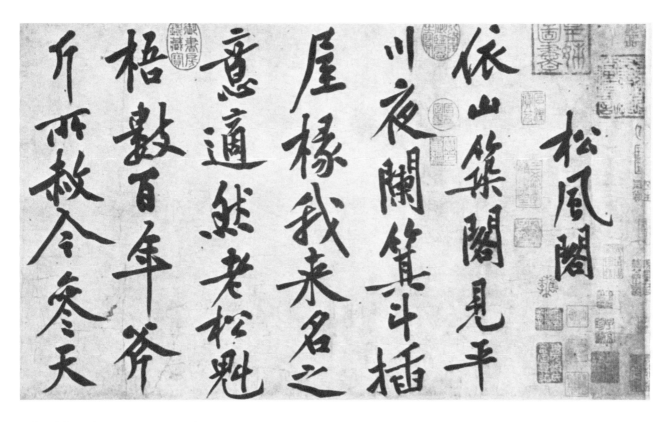

A detail from the poem "Pine Wind Pavilion" executed in Northern Sung calligraphy in ink on paper by Huang T'ing-chien (1045-1105) in 1102. From Shōdō zenshū *(Tokyo: Heibonsha, 1954).*

New Chinese Influences

The late twelfth and the early thirteenth centuries constitute the period in which Japanese monks began to journey to China, resulting in important changes in the religious, intellectual, and general cultural makeup of Japan; in particular, these exchanges brought the beginning of institutional Zen. The priests Eisai and Dōgen returned from their pilgrimages to China in precisely those years. Their surviving calligraphic works clearly reflect the new style of writing current in China, the Southern Sung revival of the Northern Sung calligraphy such as that of Su Shih and Huang T'ing-chien. The transmission of this new mode of calligraphy to Japan was not accomplished solely by Zen monks. A priest of the Ritsu School, Shunjō, also brought back this style. A comparison of Shunjō's style of writing with that of the Southern Sung Emperor Kao-tsung may be sufficient to reveal the transmission of the Sung calligraphic tradition. The Japanese responses were quick and thoroughgoing, particularly among the Zen clerics. Pilgrims travelled to and returned from China throughout the thirteenth and into the fourteenth centuries, bringing back with them a significant number of Chinese books of all sorts. This is evident from the library inventory taken in the early fourteenth century of

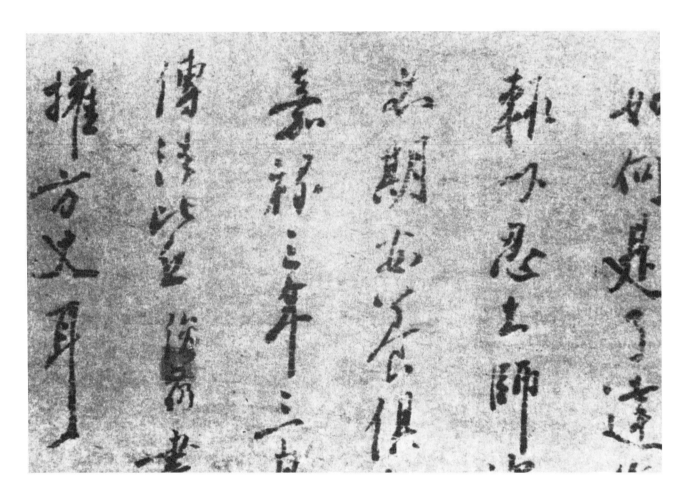

A detail from a postscript to a Buddhist encomium dated 1227 and done by the Ritsu School monk Shunjō (1166-1217) in ink on paper. From Zenrin bokuseki *(Tokyo: 1955).*

16

A rubbing of a Buddhist commemorative stela with an inscription done by Southern Sung Emperor Kao-tsung (1107-1187) and dated A.D. *1133. From* Shōdō zenshū *(Tokyo: Heibonsha, 1955).*

17

the Fumon-in subtemple of Tōfuku-ji Zen monastery in Kyoto. Among the objects the monks brought back from China were calligraphic works of contemporary as well as past masters, including Chang Chi-chih and Huang T'ing-chien. The latter was clearly emulated by the early Japanese Zen monks, and the monk Kokan Shiren (1278–1346) left a handful of calligraphic works based upon Huang T'ing-chien's Semicursive and Cursive styles of writing, dated in the fifth year of the Kemmu era, corresponding to 1338. No one was artistically more aware of the expressive potentials of Sung calligraphy than Shūhō Myōchō, better known by his title of Daitōkokushi, whose powerful calligraphy follows the Sung style, particularly that of Huang T'ing-chien, without being enslaved by it. The artistic milieu of thirteenth- and fourteenth-century calligraphy in Japan was binational. Not only were the Japanese monks visiting China, but Chinese monks were living in Japan as well. Because one Japanese

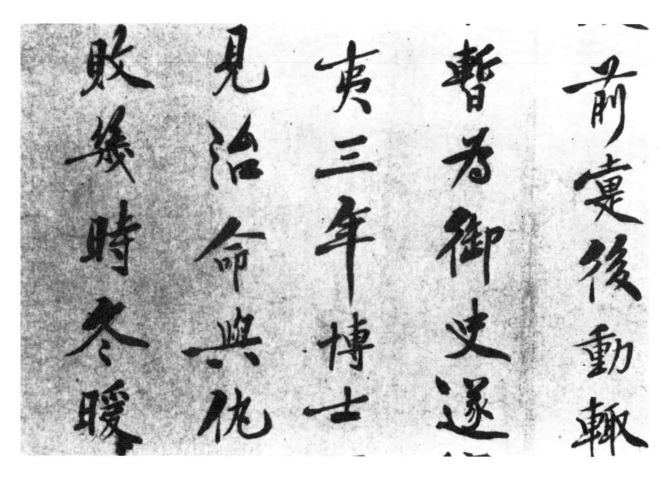

A detail from Han Yü's Key to the Advancement of Learning *done in ink on paper by monk Kokan Shiren (1278-1346). From* Zenrin bokuseki *(Tokyo: 1955).*

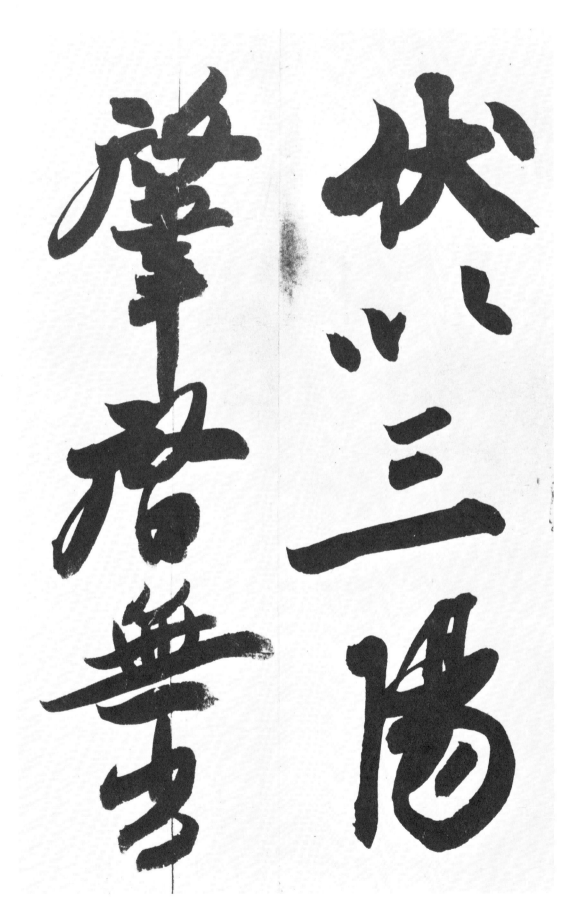

A detail from instructions for sutra recitation done in ink on paper by Sung calligrapher Shūhō Myōchō (1282-1337). From Shōdō zenshū (Tokyo: Heibonsha, 1960).

pilgrim monk at Shao-lin-ssu on Sung-shan was versed in Chinese style prose and calligraphy, he was asked to compose a long eulogy for a stele to be erected commemorating one of the temple's abbots. The stele, and its inscription, carved on monumental stone, still exist to this day at Shao-lin-ssu.

Throughout the thirteenth and fourteenth centuries Chinese monks were residing in Japan. Lan-chi'i Tao-lung was among the early arrivals. He brought with him the style of Sung calligrapher Chang Chi-chih, known mainly for his medium Standard script, but also for his informal Cursive mode of writing, which was to become an inspiring model for some Japanese calligraphers in later centuries.

The Chinese styles of calligraphy that swept through thirteenth- and fourteenth-century Japan, as we have seen, were not totally and passively absorbed by the Japanese calligraphers. There emerged, in the fourteenth century, a critical literature on calligraphy that began to pay attention to the novelty of the Sung styles, regarding them as eccentric and comparing them with the orthodoxy of the earlier T'ang calligraphy. The imperial prince, and an excellent calligrapher, Son'en (1298–1356) of the Shōren-in, wrote a calligraphy treatise, *Summary of Calligraphy (Jubokushō)*, in which he noted the polarity of styles in Chinese calligraphy —that between T'ang and Sung, orthodoxy and eccentricity, the normal and the deviant — and the continuity and disruption in the transmission of styles. He even compares China and Japan and cites the superiority of the tradition of Chinese calligraphy from Wang Hsi-chih to the T'ang now perpetuated in Japan over that of China where changes had been rampant. The orthodoxy, he continued, of Chinese calligraphy is comparable to the style of Kōzei maintained down through the early twelfth century.

俯羅聞佛所說皆大歡喜

信受奉行

金剛般若波羅蜜經

寶祐元年七月十三

日張即之奉為

顯妣楚國夫人韓氏

五九娘子冥忌以天

A detail from the Diamond Sutra done in ink on paper in 1253 by Southern Sung calligrapher Chang Chi-chih (1186-1266) in medium Standard script. From Shōdō zenshū (Tokyo: Heibonsha, 1955).

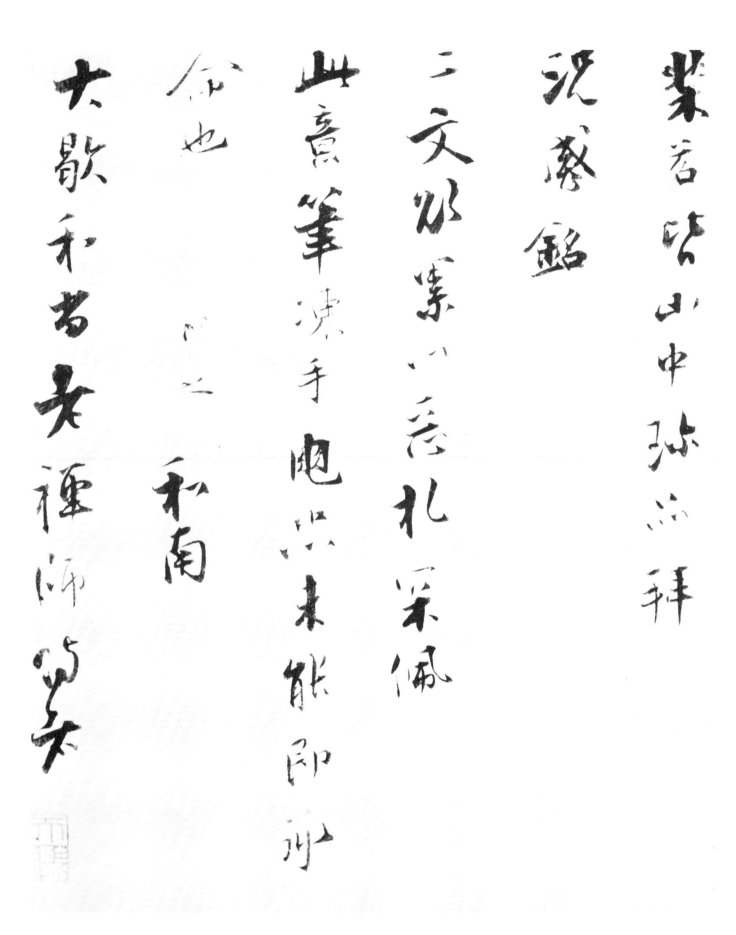

A detail from a letter to monk Ta-ho done in ink on paper by Southern Sung calligrapher Chang Chi-chih (1186-1266) in Cursive script. From Shōdō zenshū (Tokyo: Heibonsha, 1955).

Great Integration: Edo Period

By the fifteenth century, Japanese calligraphy had experienced stylistic developments on two basic fronts: *kana* calligraphy and Chinese modes, often mutually influencing each other's formal aspects. The sinuous writing mode of *kana* calligraphy and the more complex and formidable Chinese modes represented the two extremes of the Japanese aesthetic poles. To integrate them, to arrive at a synthesis, took the Japanese calligraphers a few more centuries. By the early decades of the seventeenth century we see a creative synthesis in calligraphy in the work of Hon'ami Kōetsu.

The calligraphy of Hon'ami Kōetsu demonstrates on the one hand the Cursive style of *kana* calligraphy mixed with a Cursive style of Chinese calligraphy. It shows scripts generally written with a finely tipped brush. In each column of the example shown here we see abrupt changes in the pressure of the brush within a single character or between two characters. The use of the side of the brush creates structurally dynamic strokes with contrasts between the thin and thick forms. The peculiar dynamics of the change in pressure and speed that create such contrasts of thin and thick strokes in Kōetsu's works owe their characteristics to the style of Southern Sung calligrapher Chan Chi-chih. Ever since the late thirteenth century through the Muromachi, Momoyama, and Edo periods, Chang Chi-chih had been greatly appreciated in Japan. The monk Kokan Shiren of the early fourteenth century, for instance, mentions in his treatise *Soseki ōrai* (Manual of Letter Writing) his admiration for Chang's works, remarking that Chang Chi-chih has four modes of writing: one that looks like "wisteria blossoms," and others that resemble "old trees," "scudding clouds," and "willow branches" — undoubtedly metaphorical descriptions of different modes. During Kōetsu's active years we know that *Ch'ien-tzu-wen* or the *Thousand Character Essay* copied in Chang's calligraphy was donated to Emperor Goyōzei (r. 1586–1610) by Toyotomi Hideyoshi. Among the tea aesthetes of the Momoyama and early Edo periods, Chang's calligraphy was highly popular and graced the *tokonoma* alcoves for the tea ceremonies held by affluent and cultured townsmen-aesthetes such as Sōtatsu, Sōgyū, and Sōtan.

In Chang Chi-chih's calligraphy, the extreme contrast of strokes, thick and thin, occurring within a single character as well as among characters following one after the other, can be seen especially clearly in his informal letter addressed to a certain monk Ta-ho, which is now in the Tokyo National Museum.

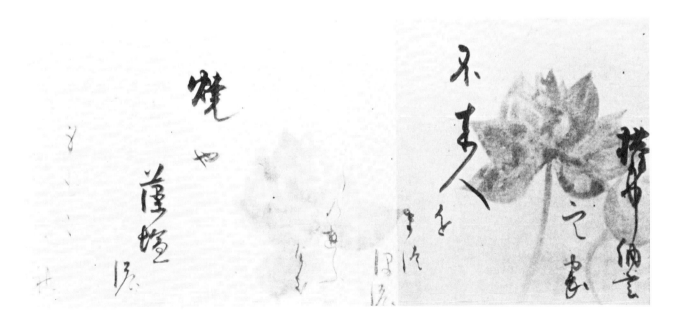

A Lotus Scroll *detail done in ink on paper. The underpainting is attributed to Sōtatsu (active circa 1600-1640) and the calligraphy is by Hon' ami Kōetsu (1558-1637) in the Cursive style of* kana *mixed with the Chinese Cursive style of script. From* Masters of Japanese Calligraphy: 8th-19th Century *(New York: 1984)*.

What we see here is the peculiarly free use of certain styles of Chinese calligraphy in the interpretative and creative hands of a Japanese calligrapher of the late sixteenth and early seventeenth centuries. Interestingly enough, Kōetsu's active years coincide with those of the formidable Chinese scholar-artist and calligrapher Tung Ch'i-ch'ang, who was then articulating his own credo concerning the artistic transmission and transformation manifested in the lineage of calligraphic traditions. He formulated the philosophical concept of criticism in calligraphy, of which certain corollary ideas can be seen in his theories of painting. Kōetsu left no such theories about calligraphy, but his works reveal the inner essence of the basic issues of transmission and transformation in art forms. Seemingly diametrically opposed traditions — Chinese modes bound to Chinese characters and Japanese Cursive calligraphy developing out of the *kana* syllabary system — find in Kōetsu's hand a creative coexistence. Kōetsu in essence creates a new tradition in which the artist's choice of elements from past models reveals a greater freedom than that available to the Chinese calligraphers, who were constantly conscious of the stylistic lineage of calligraphy transmitted by the critical tradition. In his *kana* calligraphy, Kōetsu brings out the Japanese pattern of retrieval of given forms; the problems of transmission and transformation of forms in the art of writing, like a cultural metaphor, describe much that characterized the cultures of China and Japan throughout their history.

REFERENCES

Onoe Saishū, ed., *Shōdō zenshū* (Tokyo: Heibonsha, 1954–1968), 26 vol., 2 suppl. vol.

Yoshiaki, Shimizu, with John M. Rosenfield, *Masters of Japanese Calligraphy: 8th –19th Century* (New York: Asia Society Galleries, Japan House Gallery, 1984).

CALLIGRAPHY TODAY

ON THE ART OF CALLIGRAPHY

by Aoyama San'u

One of the most distinguished calligraphers in contemporary Japan, Mr. Aoyama was first awarded the Minister of Education Award for his work displayed at the 1963 Japan Art Exhibition and has since served as a judge, councillor, and director for this important national competition. He is a member of the Japan Art Academy and a professor at Daitō Cultural University in Tokyo.

Mr. Aoyama's essay explains the ways in which a contemporary sensibility can find both authenticity and a potential for new growth in a tradition with ancient roots.

As you can see by looking at our exhibit here today, *sho*, the Japanese art of calligraphy, is a concept that encompasses a wide range of writing styles.

It may seem on the surface at least, that this art of writing with black ink on a white piece of paper —particularly in view of the fact that one can use only single strokes to achieve one's effects — is a rather simple form of art. But calligraphy can give rise to a wide range of expression as an art form. Above and beyond all the other factors involved, the major reason for this potential breadth of expression lies in the fundamental nature of the characters themselves, which form the material that is being worked with. Yet, even accepting this concept, the various expressions of *sho* that can be viewed in this exhibition are on a grand scale and give the impression that lines in motion can provide infinite variation. For calligraphy to have reached this creative point, a large number of people, over a long span of centuries, have had to contribute to its development.

In order to provide some clues as to how to interpret or understand the various items shown in the exhibition, I would like us to concentrate on several that are widely divergent in nature.

First of all, you will note that the tonality of the work created by Yanagida Tai'un is radically different from the normal calligraphic creations that you may have seen. This is because the artist has drawn with gold paint on dark blue-colored paper. For those of you who expected to view a black-and-white exhibit, this may have come as somewhat of a surprise. Indeed, gold paint's characteristics resemble those of black ink and can therefore be employed similarly. Thus, this work does not depart from traditional calligraphy in any way.

Examples of this type of creative calligraphy are frequently found in religious writings of the Middle Ages, in both China and Japan. The concept behind such creations is the same as that which resulted in the painting of Buddhist statuary in gold — to enhance a sense of religious majesty and splendor.

Now let us come back to this particular creation by Mr. Yanagida. You will note that there is an amazingly large number of words, written in the Standard script form of calligraphy. You can easily appreciate that it was no simple matter to create such an intricate work of art. As a matter of fact, Mr. Yanagida has stated that it took him four to five days to finish this piece. Although the large number of words is among the factors which resulted in this work of art taking such a long time to make, the main reason is his use of the Standard script style.

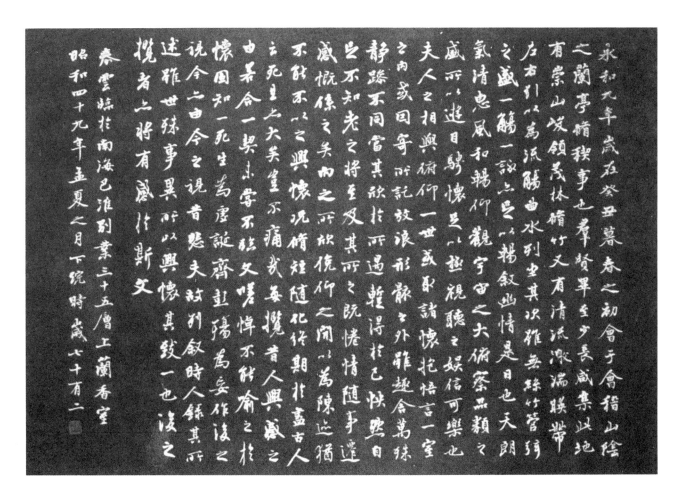

Preface to the Orchid Pavilion *(written in* A.D. *353) done in Standard style by Yanagida Tai'un, 1984.*

As is the case with two other styles, Seal script and Clerical script, each character must be written individually and separated from the other characters. When it comes to other more fluid styles of calligraphy — such as the Semicursive and the Cursive styles, as well as that used when writing the *kana* syllabary —it is possible to connect the various characters or syllables. Such is not the case with the Standard script used in this work.

As to other items in the exhibit, creations by Tonomura Randen, their overall size is not so different from that of the previous one; however, the style of writing is diametrically opposed to it. One can readily imagine that the time taken to complete it was, perhaps, one-tenth that required in the case of the previous work by Mr. Yanagida. This work, which is just as much in the genuine calligraphic spirit as the first one, is capable of producing such a different effect because of the way it was created. These two works show that calligraphy can encompass a very wide range of expression. However, what is perhaps even more important is that the worlds

these two artists intended to depict are considerably different. In the world of sports it would be like the difference between a marathon race and a 100-meter dash. In my opinion, the fact that these two artists took such divergent paths stems primarily from the differences in the human gifts with which they were endowed, since calligraphy is an art that reflects the human characteristics of its creators.

With those works of art that require a long period of time to create, as was the case with Mr. Yanagida's calligraphy, great effort is required to sustain the inspiration until the work is finished. Should the vision that the artist has in his mind become distorted, due to the passage of time, his creation will be a failure. By way of contrast, in the case of Mr. Tonomura's work, the artist must determine instantaneously the various changes in the movement of the brush and cope with a very high degree of tension or stress in a short period of time. It is the very existence of such diversity that makes that form of art known as calligraphy so attractive.

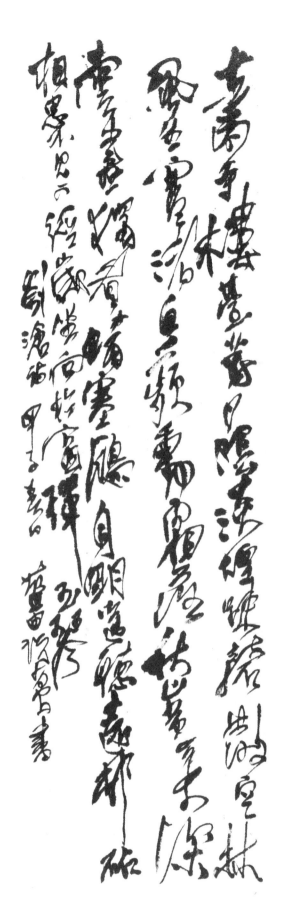

*A poem by Liu Ts'ang (circa A.D. 860) done
in ink on linen by Tonomura Randen, 1984.*

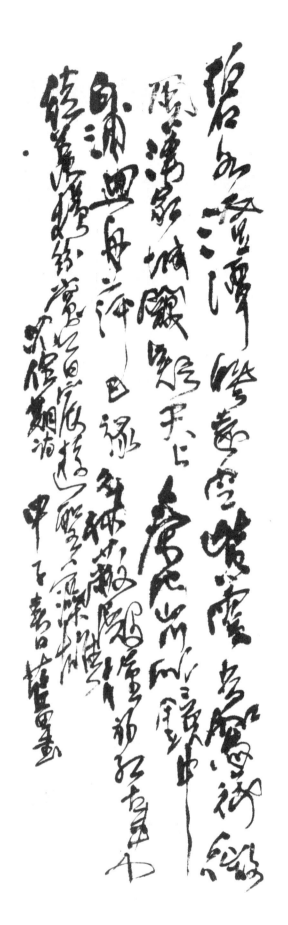

*A poem by Shen Ch'uan-ch'i (?-713);
calligraphy by Tonomura Randen.*

27

When we ponder the meaning of what past masters of the art of calligraphy have written, we can find abundant guidance for those of us who are carrying on this work today. During the T'ang dynasty in China (618–907) there was a famous Cursive style artist who was also an established writer; his name was Sun Kuo-t'ing (fl. 690). He stated the following: "In writing *sho*, the best way is to write in a casual fashion." Although open to interpretation, this statement can be taken to mean that, once an artist has the urge to create, he should just simply let himself go and do his work in a state of complete self-absorption. At the same time, the word *casual* can be interpreted in a number of different ways. It is a word full of implications.

During the Sung dynasty (960–1279) the famous artist and poet Su Tung-po (1036–1101) stated that the ideal frame of mind when creating calligraphy requires *T'ien-chen lan-man* — innocence or complete naïveté. It would seem that the best time to create calligraphy is when the artist finds himself in an unaffected frame of mind and is not disturbed by anything extraneous. As a matter of fact, Su Tung-po, in his official capacity as a politician, led a life full of turbulence, so these words held special significance for him.

In the time of the Ch'ing dynasty (1644–1912) Pao Shih-Ch'en (1775–1855) played a major role in the renaissance of calligraphy in his capacity as a theorist on ancient calligraphy writings. He stated that the concept of *Ch'i-man* is very important. What the term suggests is that unless the artist's state of mind is replete, he will not be in a position to create artistic works. When we compare this last remark with the statement attributed to the two previously mentioned artists, one can understand the continuity of attitude in this tradition.

There are a great number of other master artists who have left writings that describe their deep convictions concerning their mental states when they create calligraphy. What they contributed to the world of art grew out of a philosophy drawn from their own personal experience, as well as from what might be called an expression of their own personal enlightenment. I believe that a comparison between the works and words that such artists have left us is of considerable value, even today; for the magnificent traditions of calligraphy were created by such men.

The writings of these historical calligraphers tend to be quite complex, and it is sometimes difficult to discern their exact meaning, but we should continue to study their writings carefully to clarify what they really intended to convey. I also believe that our own humanity will be enriched by such study, so that we ourselves will then be able to create more

effective calligraphy.

Traditionally, China has been called a "country of the art of writing." The culture of old China was centered in the imperial dynasties; at a later date, members of the nobility took over. By the Middle Ages, intellectuals from among the "populace" began to be involved with art, but the art of calligraphy was separated from the illiterate people, unlike painting or craft work. It should be noted, however, that even at this later date, the word populace referred to the *shen-shih*, or "gentlemen," that segment of the larger population that had taken and passed the classical examinations for senior governmental posts. It is important to note that these classical examinations heavily stressed the importance of literary knowledge. However, those who passed the examinations were not only bureaucrats, but accomplished literati, which is one of the reasons that led to China's being referred to as a land of the art of writing.

Japan, which imported its culture from China, did not have classical examinations, in the strict sense of the word. However, starting in the Heian era, it was considered important for persons who served in the Imperial Court to be able to compose *waka*, the thirty-one-syllable classical Japanese form of poetry. I think it would be safe to assume that China influenced this attitude. The art of calligraphy was part and parcel of the intellectual life at Court. As calligraphy came to be enjoyed and respected, its importance became more widespread. Naturally, the traditions born out of such an atmosphere were rather alien to the general masses in Japan. Today, however, the situation has changed completely, for there are few illiterates either in China or in Japan.

Now we come to the question as to whether or not, in the case of the art of calligraphy, it is meaningful to merely propagate the traditions we have received from the past. In Japan this question was vigorously debated around the end of World War II. As a result, an avant-garde calligraphy movement was born, as was another movement promoting the complete discontinuance of writing based on the old classics.

One of the major questions facing such movements is whether or not it would be possible for such new forms of beauty to surpass or perhaps even triumph over the traditional ones. It must be admitted that traditional beauty, which was molded over 3,000 years, has been perfected; it would be very difficult to go beyond the beauty of traditional calligraphy.

Now, where do we contemporary artists stand on the matter? Even though it may not be possible to

rival the elite masters of olden days, we continue to rely on their methodology and are quite content with the way our art is progressing. At the same time, we are concerned over whether this is indeed the right way for us to proceed.

Two diametrically opposed ways of thinking can be observed in the world of calligraphy in Japan today. The first is based on traditionalism, and the second (which might be called a doctrine of expressionism) strives to liberate itself from the bonds of traditionalism. The *kanji* or Chinese-character schools are based on the ancient Chinese traditional styles of writing which have developed since the Middle Ages. The *kana* or syllabary schools of calligraphy concentrate their attention on developments around the middle of Japan's Heian period. During the Ch'ing dynasty in China, calligraphers returned to the ancient, classical styles of writing. This brought new life to this art. Even in Japan, a reconsideration of Heian period *kana* was conducted at the end of the nineteenth century with a resultant escape from the hackneyed styles of the Middle Ages. In today's fast-changing world even a style of calligraphy that incorporates such changes is regarded as something of a Classical movement.

What happened to the Expressionist school? Though it is acknowledged that the school could have gone in an infinite number of directions, the Expressionists have not produced works of particular note. In the short early days of avant-garde calligraphy, the artists created works based on a broad cultural background and understood Western European modern art. There were even instances of European art which had clearly been inspired by Japanese calligraphy. At the same time, one branch of the Expressionist school seems to be making steady progress, and it is encouraging to note that they do produce works of calligraphy that merit serious consideration.

As regards the effect of these two opposing schools upon my work, there are times when I am conscious of and influenced by their point of view and other times when I am oblivious to it.

In the past, I believed that calligraphy was much more of a personal, rather than a social phenomenon. Then I realized that in order for this form of art to receive the approbation of the general public, it would have to broaden its artistic concepts. I also used to think that an understanding and appreciation of calligraphy was only possible in the *kanji*, or Chinese character-using countries — such as China, Korea, and Japan. So I am very happy that the art of calligraphy has been taken up in this forum.

Finally, I would like to discuss the relationship between the art of calligraphy and the poetry of one of modern-day China's great leaders, former Chairman Mao Tse-tung.

During his revolutionary days, Mao composed a number of poems in the classical style. At the same time that these poems celebrated the struggles of the revolution, they also praised the magnificent mountains and rivers of Mao's native land. It is interesting to speculate how Mao found time to practice this art when he was so heavily engaged in revolutionary activities.

After the revolution, Mao wrote an extremely interesting letter to an associate of his who had visited him to ask about having these poems eventually published in an anthology. When the poems were published this letter was included as the preface:

> Up to now I have never wanted to make these poems known in any formal way, because they are written in the old style. I was afraid this might encourage a wrong trend and exercise a bad influence on young people. Besides, they are not up to much as poetry, and there is nothing outstanding about them. However, if you feel that they should be published and that at the same time misprints can be corrected in some of the versions already in circulation, then publish them by all means.

Almost all of Mao's poems have been published and they are also well known to anyone who has had the opportunity to visit China recently, as they are frequently reproduced in greatly enlarged form on walls. I myself always examine these writings when the opportunity presents itself, as I consider them to be outstanding calligraphy, as are many modern-day Chinese works.

At first sight, Mao's writings may appear unconventional; however, they incorporate the finer points of traditional Chinese calligraphy. What is particularly striking is the apparent influence of Hsu Wei (1521–1593), who lived during the middle of the Ming dynasty and was known as a mad genius of poetry, calligraphy, and art. Though unrecognized during his lifetime, after his death he was rated among the highest practitioners of his art. Of even greater importance is the fact that we can observe glimpses of the Sung dynasty master calligrapher Mi Yuan-chang (1051–1107) in Chairman Mao's calligraphy.

I am not aware of any serious discussion in present-day China of Mao's calligraphy; however, I have no doubt that his work will be noted as part of the history of this art. When we look at Chairman

Mao's calligraphy with an eye to positioning his accomplishment, even if we compare his works with those of the Romantic school artists who flourished during the latter part of the Ming dynasty, they need not take second place to any others. If then we assume that a work of calligraphy is a reflection of the human characteristics of its creator, it would mean that Chairman Mao was a Romanticist. Not having made any serious study of the Chairman himself, I cannot be absolutely certain; but, to the extent that it can be observed by examining his calligraphy, I have come to this conclusion.

I continue to be fascinated by that letter which serves as the preface to Mao's poetry. The chairman was concerned about the gap between himself and the generation to follow. When I examine my own calligraphy I find a common thread between the two of us which makes me sympathize with the Chairman's ideas and feelings.

CONTEMPORARY JAPANESE CALLIGRAPHY — BACKGROUND AND GROUND
by Elizabeth ten Grotenhuis

Elizabeth ten Grotenhuis received her Ph.D. in 1980 from Harvard University, specializing in the history of Japanese art. Since then she has been an Associate in Research at the Japan Institute at Harvard, often lecturing in the Boston area. Among her publications are translations and adaptations of Japanese works on Buddhist painting and narrative picture scrolls; and she was the author, with John M. Rosenfield, of the catalog for the 1979 exhibit sponsored by the Asia Society in New York, *Journey of the Three Jewels: Japanese Buddhist Paintings from Western Collections.*

Dr. ten Grotenhuis's essay examines the works of calligraphy displayed in the exhibit "Words in Motion" and discusses them in terms of both their relevance to the traditions of the past and their relations — explicit and implicit — with the international world of contemporary art, in which the Japanese now participate as fully as in the spheres of commerce, industry and technology.

Today is June 15, the day that Japanese Buddhists of the esoteric Shingon sect celebrate the birth of the founder of their sect, Kūkai or Kōbō Daishi. Kūkai, who lived in the late eighth and early ninth centuries (774–835), was not only a brilliant monk-scholar who journeyed to China and brought new Buddhist teachings back to Japan. He was also a great cultural leader and a superb calligrapher, who introduced new Chinese calligraphic styles to this country and helped articulate, for the first time in Japanese, aesthetic theories of calligraphy. Appropriately enough, the cover of the catalog of this exhibition of contemporary Japanese calligraphy at the Library of Congress shows one of the calligraphies attributed to Kūkai.

Kūkai was considered one of the three outstanding, early-Heian-period masters of calligraphy as well as the patron deity of Japanese calligraphers, and he spoke with authority when he said "a poet should learn the styles of olden times but not imitate them; a calligrapher should absorb the spirit manifested in ancient works but not copy them."[1]

I feel that if Kūkai could be with us today to view this important exhibition of twelve contemporary Japanese calligraphers, he would be pleased to see that his dictum of almost twelve hundred years ago was being executed faithfully. These calligraphers have modeled themselves on past masters, on traditional scripts, and they have drawn directly from their literary heritage, but they have then transcended these models to create unique and impressive works. Because of the way these calligraphers write, they have been aptly called "creative traditionalists." They reinterpret many styles, creating modern interpretations of the ancient, time-honored scripts. One of the artists in the Washington show, Kamijō Shinzan, has defined the type of writing this group creates as *gendai rinsho* or "contemporary-modern interpretations of the masters." Different sources and influences, scripts and styles, seem to converge in the works of these contemporary calligraphers. And twentieth-century international influences cannot be dismissed either, although these calligraphers are more focused on their East Asian heritage.

The Chinese literary legacy looms large in this exhibition, as is evidenced by the types of script used and by the literary works to which the calligraphies make reference. This emphasis reflects the Edo period (1603–1868) experience when Chinese historical studies became very popular in Japan. The five types of Chinese script — Seal, Clerical, Standard, Semicursive, and Cursive — are all represented in the exhibition.

One aspect of this exhibition which particularly interests me is the reverence paid to the ancient scripts, particularly the Seal, but also the Clerical script. The Seal script is among the oldest forms of written language in the world, having developed in China in the first millenium B.C.; traditionally, when writing Seal script, the brush was used in imitation of a stylus, denying that modulation of line that is characteristic of the other script forms. These contemporary calligraphers have changed all that; their modern-day interpretations of the Seal script exhibit spontaneity, modulation, and fluidity, reflecting many other influences, including a twentieth-century playfulness and interest in pictographic or hieroglyphic form.

The Library of Congress calligraphers, all trained before the Second World War, could justifiably be termed a "conservative" group, especially when compared to some of the other Japanese calligraphers active today. The calligraphers in the Library's show always remain closely attuned to, and in touch with, the literary content of the shapes and forms they create; in short, they are always writing words. Some of the more avant-garde contemporary Japanese calligraphers create compositions that they call calligraphic, but which are pure, abstract forms not based on any word, concept, or literary symbol. I would like to dwell for a moment on the avant-garde calligraphy movement in Japan, although it is not a very large group, because I think we can define who and what the Library of Congress calligraphers are in part by showing what they are *not*. The avant-garde artists, who draw on their technical calligraphic training but not on their literary heritage, often call themselves part of the *bokushō* (Ink-Images) movement; from our Western and particularly American perspective, we might call them the abstract expressionists of the Japanese calligraphy world.

The *bokushō* movement, which is a post-World War II phenomenon, is a synthesizing movement in which modern Western artistic values have been thoroughly assimilated. One example from this contemporary abstract calligraphy movement is a work by Takeshi Sōfū, an artist who creates purely subjective, expressive forms. His work contrasts quite effectively with the calligraphies in the Library's show which do not stray as far from tradition as do the avant-garde, abstract works. The works of the Library's calligraphers are by no means slavish and uninteresting imitations of the past, but can be viewed as contemporary expressions of a tradition several thousand years old that embraces the entire history of China and Japan.

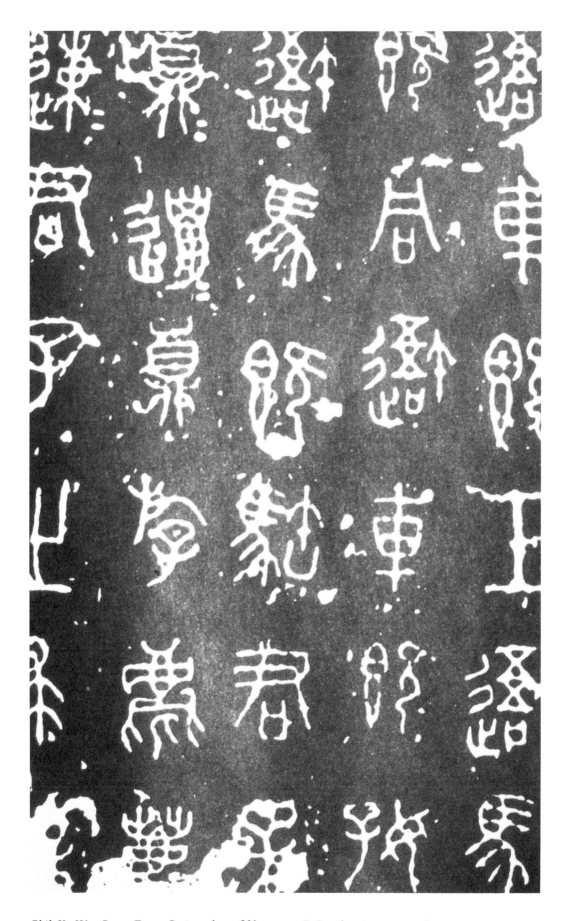

Shih Ku Wen Stone Drum Script, about fifth century B.C., showing a stage of transition from great to small Seal script.

Contemporary abstract calligraphy by Takeshi Sōfū.

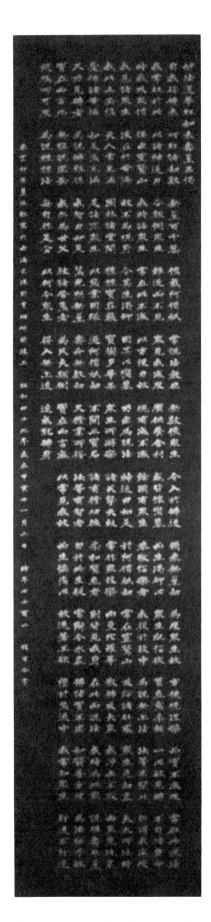

The Lotus Sutra, *done by Yanagida Taiun, in ink on paper (1974).*

I wish I could discuss each of the Library's calligraphers in depth. Time will not permit that, but I would like to mention one of the artists at the outset — Yanagida Taiun — because, in my opinion, some of the most unusual and traditional pieces in this show were done by this one man. The fact that one artist can work in such diverse manners should remind us of the danger of trying to label and pigeonhole the work of even one man, let alone the work of a group. Yanagida's careful copying of Buddhist holy texts or sutras is a latter-day expression of piety and devotion that stretches back to the sixth and seventh centuries A.D. in Japan, to the time when Buddhism was introduced and assimilated from the continent; the tradition goes back several hundred years further in time in China. This rather conservative piece is done in Standard script. We will discuss shortly the use of gold ink on a dark blue background, a manner of coloring that can be traced to eighth-century China.

In contrast to this traditional piece by Yanagida is his version of a poem by Han-shan, written in an eccentric style that seems entirely appropriate to the content of the poem. Han-shan was the semilegendary, eccentric recluse-poet who lived sometime in the T'ang dynasty (618–907) and who was adopted by the Ch'an (Japanese Zen) sect into its pantheon as a paradigm of an enlightened being. In this poem (and its mate) Yanagida based himself, quite loosely, on the ancient Seal script. The calligraphy, apart from its literary content, seems, however, to have more in common with certain twentieth-century compositions, such as those by Miró and Klee, than with the ancient Seal script. In the "Words in Motion" catalog, Yanagida says of the poems, "This arrangement is original, with no precedents. The calligraphy is as unusual as the poems themselves." These are clearly works which could not have been created in any century other than our own, but they nonetheless recall a writing script well over two thousand years old — a remarkable juxtaposition of ancient and modern modes of expression.

Having discussed something of the background of the exhibition, I would now like to move to another topic — the relationship between ground and brushstroke. Let us look carefully at the interaction between the surface of the paper on which the characters are written and the inked symbols themselves. We will see how many of these Library of Congress calligraphers are clearly indebted to the Japanese tradition of employing colored, decorated papers, and yet how their works are fresh, modern-day reinterpretations of that tradition.

"Cold Mountain," a poem by Han-shan; calligraphy by Yanagida Taiun, in ink on paper.

Mi Fu, the great eleventh-century Chinese calligrapher, claimed that he wrote "with all four sides" of his brush, suggesting not only that he used all of the physical surfaces of the brush tip, but also that he felt that the paper or silk on which he wrote extended into the space beyond or behind it.[2] All the great calligraphers have managed to create the impression of a three-dimensional space within which the brush seems to move. And certainly this impression can be conveyed with black ink on white or pale paper or cloth alone. The importance of the spatial setting can be particularly emphasized, however, by the use of colored, decorated papers, as in the mid-twelfth-century *Heike Hōhyō*, the collection of sutra texts dedicated to Itsukushima Shrine by the aristocratic Taira family in 1164. Colored, decorated papers like these seem to act like a deep pool or like the sky, allowing the written symbols to float up and down or drift along on their surfaces. The Japanese, more than the Chinese, seem to have been interested in and to have exploited the potential of using colored, decorated papers in their calligraphic masterpieces. In many examples of traditional Japanese calligraphy, color and decoration serve important expressive functions. The same is true for many of the calligraphers represented in the Washington exhibition.

Paper was first used in China as stationery in about the first century A.D., although it was very likely invented several hundred years earlier. The technique of papermaking probably reached Japan in the late fifth century, although the oldest extant examples of Japanese paper date from the eighth century. These eighth-century examples are found in the Shōsō-in collection of the household items of Emperor Shōmu, which were dedicated to the great temple of Tōdai-ji in 756 and 758 after the emperor's death. The Shōsō-in collection includes a dedicatory record describing the calligraphies of the immortal fourth-century Chinese calligraphers Wang Hsi-chih and his son Wang Hsien-chih, written in Standard script with sumi ink on blue hemp paper. The so-called *torige tensho byōbu*, a six-fold screen in the Shōsō-in collection, shows a text in Seal and Clerical script written on pale yellow and green decorated papers. Crimson paper *(benigana)* is mentioned in Shōsō-in documents as well.

Buddhist sutras were written on pale-colored paper, often a pale yellow color that was used not for any expressive reason but because that was the color the paper turned when it was treated with a substance to preserve it from insects. This insecticide had its origins in China. Also originating in China, but seen to a far greater degree in Japan, was the custom of inscribing the holy texts with gold and/or silver ink on indigo-dyed paper which was a handsome, dark blue-purple color. We have already touched on the incorporation of this tradition in

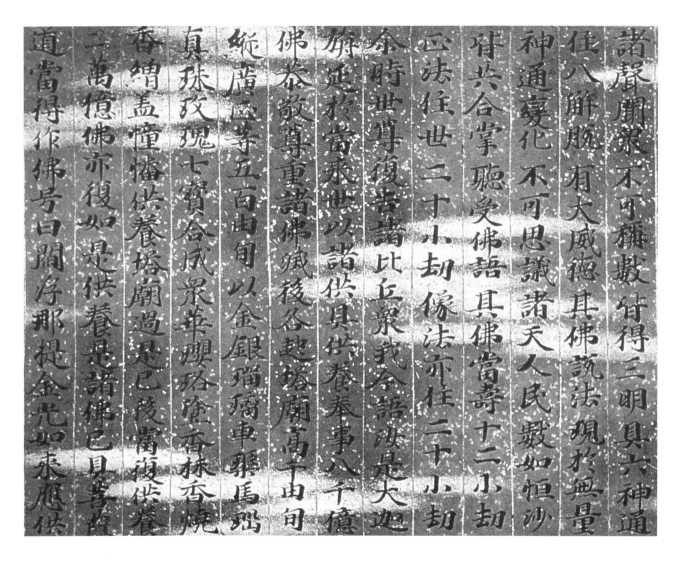

The text of the Lotus Sutra, *in ink on decorated papers, from the* Heike Nōgyō *collection,*
dedicated by the Taira family to Itsukushima Shrine in 1164.

some of the calligraphies by Yanagida Taiun. Using gold and silver on indigo blue clearly served an important symbolic or expressive function. Gold and (to a slightly lesser extent) silver had symbolized religious purity and truth from the earliest times of Brahmanic speculation in India. The place where the historical Buddha Śākyamuni attained supreme enlightenment is often termed *suvarnavarna*, or "gold-colored." The association of gold and dark blue, however, seems to have its origins in China, where dark blue or purple was a color that had long suggested sanctity or nobility to the Chinese. The Chinese word describing several types of formal wear and official attire worn by the aristocracy incorporates the character for dark blue. There are also at least four different terms which signify a Buddhist temple, all of which include the character for dark blue. Using gold and silver on a dark blue-purple ground was an expressive manner employed by calligraphers, painters, and lacquer decorators from the eighth century onward in East Asia.

During the course of the eighth century various techniques for decorating paper were explored and developed in Japan. These included stamping, stenciling, gilding with small pieces of gold and silver leaf, and washline drawing. It was, however, during the ensuing Heian period (794–1185) that the art of papermaking and paper decorating was perfected, in

36

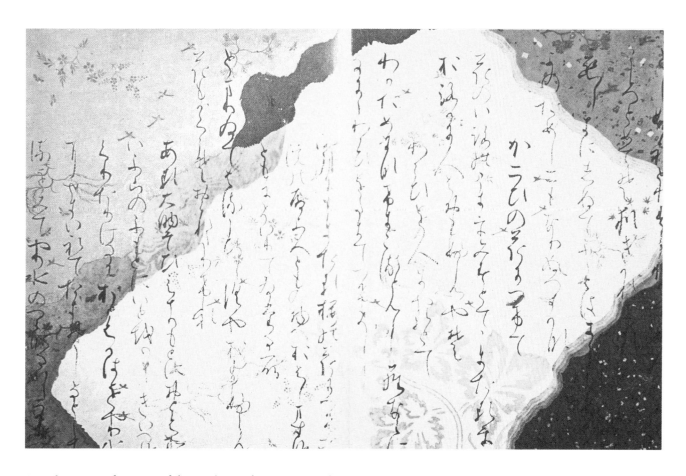

An ink on paper fragment of the Ise-shū, "Ishiyama-gire," from the twelfth-century
Sanjūrokunin Kashū (Collection of the Thirty-six Master Poets).

terms of both quality and variety. Papers were dyed
many subtle shades; a number of these hues, made
from indigenous plants, were unique to Japan. This
would be one reason why some of those shades of
paper were not seen in China. But more than that,
the Japanese seemed intrigued by the possibilities
for decorating paper. It is true that in China, partic-
ularly during the Ming period (1368–1644), we do
find gold or gold-flecked paper, and some paper with
stamped or block-printed designs, but we never see
on the continent the wealth of sumptuously, even
riotously, decorated papers as in Japan.

There are many magnificent examples of colored,
decorated papers in Japan, from the Heian period
and later, reflecting a native Japanese, aristocratic
taste. Certainly a touchstone for magnificence is the
early-twelfth-century compendium originally in the
temple of Nishi Hongan-ji, the *Sanjūrokunin Ka-
shū (Collection of the Thirty-Six Master Poets)*, in
which many kinds of inventively ornamented ex-
quisite paper may be found. In the section re-
produced here, various subtly shaded papers are

juxtaposed in a collage arrangement that pulsates
with a suggestion of three-dimensional space. Mica
powder, gold and silver flecks, and gold and silver
designs are added, and some of the paper is marbled.
Kamijō Shinzan has used similar collage and deco-
rating techniques effectively in one of his works in
the Library's exhibition. The background paper is
covered with a subtle, block-printed design, and
gold and silver flecks are sprinkled over the deli-
cately colored and arranged papers, which suggest a
spring setting.

In this exhibition Kuwata Sasafune acknowledges
his debt to the Heian period. He says in the catalog,
"Among the writings of the ancients the *kana* sylla-
bary of the Heian period are outstanding. When I
saw them in reproductions and then in the originals,
I was so strongly moved that I resolved to gamble my
whole life on the study of these *kana* works." As
shown here, Kuwata's work offers a portrait of a
tenth-century female poet, seated in full court cos-
tume beside a lightly brushed rendition of one of her
poems. This poem is from the compendium of the

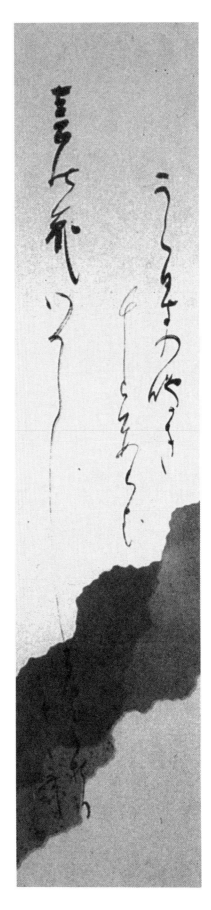

An ink on paper collage of "The Nightingale," done by Kamijō Shinzan (1983).

An ink on paper rendition of "The Power of Love," a tenth-century poem, done by Kuwata Sasafune (1984).

Koōgimi, portrait and poem from the early-thirteenth-century Sanjūroku Kasen-e (Collection of the Portraits of the Thirty-six Master Poets).

Miyamoto Chikukei's ink on paper screens (1981) make literary reference to the Hyakunin isshu (A Hundred Poems by a Hundred Poets) *of the late twelfth and early thirteenth centuries.*

An ink on paper frontispiece to a scroll of the Heike Nōgyō (Lotus Sutra) *which was dedicated by the Taira family to Itsukushima Shrine in 1164.*

40

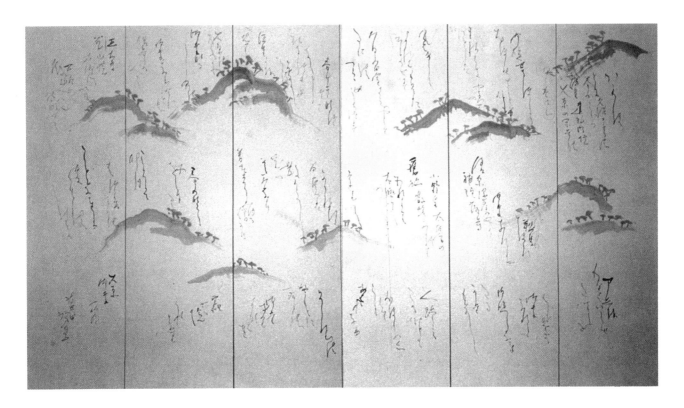

Tonomura Randen's ink on paper screen (1983) which relates the thirteenth-century tale of the Cloistered Emperor's excursion through the hills of Ohara.

work of the thirty-six master poets, the *Sanjūrokunin kasen*, first compiled by Fujiwara Kintō in the early eleventh century. From the late Heian and Kamakura (1185–1336) periods on, portraits of the poets were shown with examples of their poetry. A comparable presentation of a female poet and one of her poems from the early-thirteenth-century Satake segment of the *Sanjūroku Kasen-e* appears here. Kuwata must have commissioned a painter well trained in the native Nihonga (Japanese painting) tradition to copy the earlier, thirteenth-century portrait so that he would have a suitable setting for his own graceful version of the poem.

Some of our Washington calligraphers have created brilliant decorative works that ultimately owe something to the Heian aesthetic. Others, however, seem to be more indebted to the Edo period revival of courtly taste, which was a reinterpretation of that earlier aesthetic. Miyamoto Chikukei's pair of unique and masterful screens make literary reference to a late-twelfth- or early-thirteenth-century anthology of classical Japanese poetry, the *Hyakunin isshu (A Hundred Poems by a Hundred Poets)*. We also recollect earlier decorative achievements, such as a sutra frontispiece from the mid-

twelfth-century *Heike Nōgyō*, where brightly colored petals are blown by the wind, creating a seemingly random, brilliant asymmetrical pattern. Miyamoto's screens probably could not have been created, however, without the intervention of the Edo period, which has contributed a playful, exuberant quality. The fact that Miyamoto has used *playing* cards is in itself significant. In Miyamoto's screens the calligraphy is written on many small pieces of brightly colored and decorated paper which are being scattered by the wind over what appears to be the ocean, full of a multitude of little waves. There is a suggestion of three-dimensional space, although the bold and dramatic composition is essentially abstract in its patterning. Nevertheless, here truly are "words in motion," blown and scattered by the wind. Miyamoto himself identifies this type of writing and composition as *chirashigaki*, or "scattered writing," a traditional *wayō* or Japanese style of calligraphy in which characters and the syllabary are grouped in such a way as to harmonize with the background space.

Three-dimensional space is certainly suggested in the work of Tonomura Randen — for example, his screen relating the Cloistered Emperor's excursion

*An ink on paper
screen of "Modern
Poems on the Four
Seasons" (left,
summer; right,
spring), done by
Kuwata Sasafune
(1984).*

"Red and White Plum Trees," a pair of screen paintings in ink and colors on gold by Ogata Kōrin (1658-1716).

through the hills of Ohara. The text comes from a thirteenth-century chronicle, *The Tale of the Heike*, and Tonomura acknowledges some design indebtedness to the work of the Edo period Rimpa or Decorative School master Ogata Kōrin (1658–1716). The tops of the lines of the calligraphy echo the rounded forms of the hills: what a masterful way to suggest the movement of walking through the hills.

The legacy of Ogata Kōrin is evident in a two-pane screen by Kuwata Sasafune, the lower portion of which shows a meandering stream that immediately calls to mind Kōrin's pair of screens, "Red and White Plum Trees," in the Atami Museum. Looking more closely at the calligraphy on the sheets above the painted stream, we see that these decorated papers provide a somewhat three-dimensional as well as a conceptual setting for the graceful calligraphy on their surfaces. The spring irises, to the right of the summer wisteria, are varied in size and suggest depth. They also allude to the other famous pair of screen paintings by Kōrin of irises at Yatsuhashi. The use of silver to create the background wisteria and irises is a traditional technique that conveys a shimmering, luminescent sense of elegance.

And, finally, we can compare Hibino Gohō's delicate calligraphy, written over a scene of deer frolicking amidst grasses, with a portion of the famous early-seventeenth-century "Deer Scroll," also in the Atami Museum. The deer on this earlier scroll, rendered in simplified lines of gold and silver, were probably painted by the decorative artist Nonomura Sōtatsu (?–1643?) to complement the slightly mannered, elegant calligraphy of Hon'ami Kōetsu (1558–1637). Sōtatsu himself may have been making reference in his painting to the midtwelfth-century painting of a deer on a *Heike Nōgyō* sutra frontispiece with which, tradition holds, he was probably familiar. Sōtatsu, Kōetsu, and Kōrin are all loosely associated in the Rimpa, the Decorative School of the early to middle Edo period. Hibino's work, which is also a collaborative effort between the calligrapher and a traditional Japanese-style artist who rendered the deer, the flowers, and the grasses, includes slightly more detail in terms of the decorated background or setting. The three deer turn and twist, gracefully moving in space as does the calligraphy itself, creating a true harmony between picture and words, ground and brushstroke.

"Summer Snows on Mount Fuji," in ink on paper, by Hibino Gohō (1963).

Notes

1. Yoshito S. Hakeda, *Kūkai: Major Works Translated, with an Account of His Life and a Study of His Thought* (New York: 1972), p. 4.
2. Richard Barnhart, "Chinese Calligraphy: The Inner World of the Brush," *Bulletin of the Metropolitan Museum of Art* (April-May, 1972): 238.

References

Tseng Yu-ho Ecke, *Chinese Calligraphy* (Boston: 1971).

Komatsu Shigemi, *Heike Nōgyō no kenkyū (Study of Sutras Dedicated by the Heike/Taira family to Itsukushima Shrine)* (Tokyo: 1976), 3 vols.

John M. Rosenfield, et al., *The Courtly Tradition in Japanese Art and Literature* (Cambridge, Mass.: 1973).

Yoshiaki Shimizu and John M. Rosenfield, *Masters of Japanese Calligraphy, 8th–19th Century* (New York: 1984).

Nakata Yujirō, *The Art of Japanese Calligraphy*, trans. Alan Woodhull, Heibonsha Survey of Japanese Art (New York: 1973).

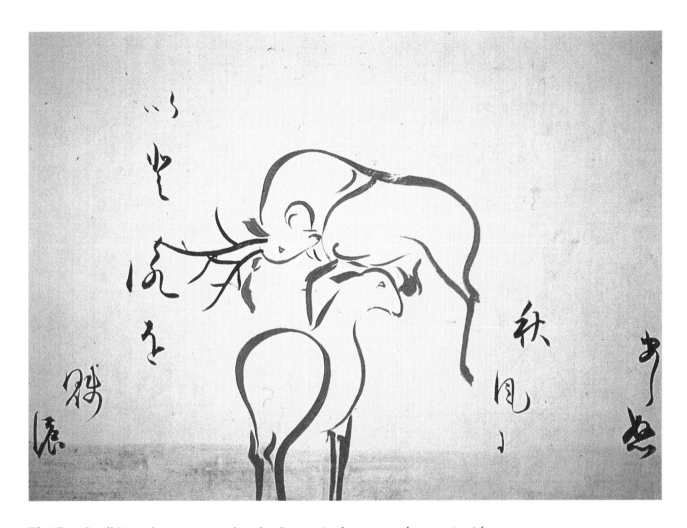

The "Deer Scroll," in ink on paper, attributed to Sōtatsu (early seventeenth century); with calligraphy by Kōetsu (1558-1637).

An ink on paper frontispiece to a scroll of the Heike Nōgyō (Lotus Sutra) *which was dedicated by the Taira family to Itsukushima Shrine in 1164.*

MEANING AS LANGUAGE

The Art of Translation

Papers from the Symposium
"Japanese Literature in Translation"

 On May 17 and 18, 1979, the Library of Congress sponsored a symposium on translation from the Japanese, part of a national program entitled "Japan Today," which introduced American audiences around the country to the contemporary Japanese cultural scene — literature, theater, and the fine arts.

While the visual and musical arts may appeal directly across cultural barriers, the written word, bound as it is to the complexities of language, requires transposition and translation to permit its meaning, significance, and beauty to be explicated and revealed. The presentations and discussions that made up this symposium were particularly lively, and the essays reproduced here were chosen from a larger number presented in order to illustrate the various difficulties, challenges, and pleasures faced by translators from Japanese into English. It is through the thin and sometimes perilous conduit of translation that important Japanese works in the humanities and social sciences manage to reach English-language readers, and each essay addresses one or more of the challenges involved.

At Gofuku-bashi Street. Takehisa Yumeji, 1914.

TAKEHISA YUMEJI

by Shojo Honda
Japanese Section
Asian Division

 The illustrations in the next two sections of this book are taken from the works of Takehisa Yumeji (1884–1934), a painter and illustrator often referred to as the modern Utamaro because of his beautiful renderings of women. For many critics, he captured, more than any other artist, the look and spirit of the Meiji (1868–1912) and Taishō (1912–1926) periods in a way that no official art was ever able to accomplish. For those interested in a more avant-garde art, on the other hand, he has been disparaged for "not having the natural makings of a painter," and criticized because "he didn't know what art is supposed to be."

Takehisa began his work as an illustrator almost by accident, but his unique style with its evocative and lightly sentimental beauty was quickly appreciated by readers of the newspapers and magazines that carried his work, and he was soon widely admired as an artist who could capture in his drawings the kind of yearning for a cosmopolitan Japan that was so important to the concepts of culture and politics in the Taishō era.

Moreover, Takehisa was a lyric poet in his own right. One of his poems, *Yoimachigusa* (Evening Primrose), was set to music and remains popular even today. The same is true of his artistic work, which, even after half a century, still pleases the Japanese because of his success in evoking the kind of nostalgic reverie that became his special property.

Takehisa was born on September 16, 1884, in Okayama Prefecture. His father managed a sake brewery. Takehisa was fond of drawing even in his childhood, and he was first given instruction in pencil sketching at higher elementary school. His art teacher often took his pupils outdoors and encouraged the students to make sketches directly from nature; thus Takehisa was able to learn his art in an environment free from any fixed doctrines.

In 1899 he entered high school in the city of Kobe, but had to withdraw from his studies because of the failure of his father's business. In 1901, when he was eighteen, he made the decision to study literature and went to Tokyo, where he managed to earn a precarious livelihood by making newspaper and milk deliveries. A year later, in 1902, encouraged by his father, he entered the school that is now Waseda University, graduating three years later. While

there, he participated in the exhibitions held by the Hakubakai, an important institute for the study of Western painting founded by the first distinguished oil painter in modern Japan, Kuroda Seiki (1866–1924).

During this period, Takehisa became a close friend and colleague of an associate of Kuroda, the romantic and highly accomplished painter Fujishima Takeji (1867–1943), whom he came to regard as his mentor and teacher for the rest of his life. In later years, even when Takehisa took up the art of illustration and of woodblock printing in addition to painting, the inspiration he gained from Fujishima remained strong.

In 1905, the artist shared quarters with a young socialist, Arahata Kanson (1887–1981), who was to have a long and stormy career in Japanese politics. Takehisa found himself interested in the socialist movement and soon became involved with Kanson's group, the Heiminsha. Thanks to Kanson's recommendations, Takehisa's antiwar caricatures of the Russo-Japanese War (1904–5) were carried in the newspaper published by the Heiminsha only two months after the famous naval battle in the Japan Sea. These drawings brought him considerable notoriety, and by 1907 he was in charge of all illustrations for the Heimin newspaper.

In 1906, his drawings were included in a new literary magazine edited by Shimamura Hōgetsu (1871–1918), a leading poet, and, after Takehisa contributed a series of sketches to the famous Yomiuri newspapers, his name became quite widely known. In the period after the Russo-Japanese War, more and more magazines, many aimed at women and young people, began to appear in great profusion and his works appeared in many of the most important of them. These drawings showed little of the earlier political preoccupations of the war period but rather revealed a note of sweet melancholy, attractive to virtually all who saw them, which soon came to be characterized as the "Yumeji Style."

In 1909 the first of his collected drawings appeared under a single cover. Entitled *Haru no maki* (Spring Series), the volume went through an unprecedented number of printings. Various collected editions of his illustrations now began to appear, and he quickly became the favorite illustrator of his time. He held his first exhibition of his paintings in 1912, in Kyoto, where his one-man show outdrew a prestigious art exhibit sponsored by the Ministry of Education. He was then only twenty-eight years old. As Takehisa became more and more popular, he began to withdraw himself from the activities of the socialists with whom he had been associated. He

had firmly set his mind on painting, and his mature view of society, differing from that conceived by the political leaders and intellectuals of the time, was grounded on a sense of a universal humanism resonant of a kind of utopian view of the perfectability of man.

Takehisa Yumeji's work is generally described as lyrical, and his yearning for a utopia became the motif of his work for the rest of his life. "I had no intention of becoming a painter," he once wrote. "I wanted to be a poet. However, my poetry would not provide my daily sustenance. One day, I tried, instead of representing poetry in words, to delineate poetry in the style of painting." His work thus maintains a configuration close to his own most personal feelings. This poetic state made visible incorporates and communicates his yearning for freedom and happiness, as well as the pathos and sweet melancholy associated with his sense of the transience of love. Indeed, his entire life was colored by his search for love and his desire to travel. By 1931, the artist had managed to extend his travels beyond Japan, going as far as the United States and Europe. Two years after his return he fell ill and died quickly on September 1, 1934. He was only fifty.

Translated by Philip Nagao
Japanese Section
Asian Division

TRANSLATING FICTION

TRANSLATING CONTEMPORARY JAPANESE FICTION
by Howard S. Hibbett

Howard S. Hibbett teaches Japanese literature at Harvard University, with a particular emphasis on fiction and popular culture from the seventeenth century to the present. Among his publications are *The Floating World in Japanese Fiction* (Oxford University Press, 1959) and *Contemporary Japanese Literature* (Knopf, 1977). He has translated the work of a number of modern Japanese authors, including Tanizaki Jun'ichirō.

Mr. Hibbett's essay deals with the challenges involved in choosing works to translate from among the wealth of conflicting possibilities available, and he describes as well the process by which a successful marriage can be achieved between the original work and its English version.

The Puppet Play at Bunraku Theater. Takehisa Yumeji, 1913.

The problem of what is contemporary is not in the least difficult in Japan, where the literary historian simply begins with the reign of the contemporary Shōwa emperor in 1926, although there is a more recent tendency to view contemporary literature as the writing which has appeared since the end of the Second World War. In any case, the uncomfortable fact is that it keeps going on and on, and we have to content ourselves with always being more or less out of date.

The latest magazines not only pour from the printing presses in extraordinary volume in Japan, but a remarkable number of them are devoted to literature. And in Kanda, the most concentrated book-selling section of Tokyo, one of the shop windows displays, with the daunting label of "Today's Books" ("Honjitsu no hon"), an impressive shelf of literary studies published that very day, actually only a fraction of the production. The rather melancholy thought of trying to keep up with all that is particularly appropriate to a literary discussion concerning Japan today.

So I come to the ever exacerbated problem of selection, not only of what to translate but what to read, even if one had all the time and facility in Japanese that one might possibly wish. It is at this point that the translator feels somewhat envious of those who deal with safely certified classics, however inadequate their annotation. Classics are, or ought to be, nicely bound volumes that you can range on your shelf and delve into without a haunting fear of wasting time on ephemera. Yet even the editing and publication of literary classics is a growth industry in Japan, and there seems to be an accelerating tempo of canonization as more and more classics are being discovered. We now have Meiji period (1868–1912) classics and modern classics; and perhaps a vast collection of Shōwa classics is being annotated at this very moment.

Indeed, not only individual works but more and more authors are being elevated to this imposing rank. Of course, it has long been a tradition in Japan for any writer worth his salt to have had his collected works issued several times within his own lifetime. What is new is the rate at which this kind of effort on the part of the publishing industry seems to be increasing. It is quite impossible for any individual person, or even almost any library, to buy and house all these collected authors. If a student is told that such and such a writer is worthy of this degree of attention, and then begins poring through these volumes which may well contain everything from casu-al journalism to obscure juvenilia, there is every likelihood that the quest for literary treasures will be abandoned in despair.

So we certainly face an increasing difficulty of choice as we approach the present, and yet the convergence in time provides us with a distinct advantage contextually, and with the possibility of sharpening the focus of our reading and translation. We are dealing with contemporary language; we can draw on our own experience in Japan, or the help of any Japanese people who happen to be at hand; we are likely to have already a fairly good idea of the background or milieu of the work.

For example, I once translated a story about a young couple living in cramped quarters in a Tokyo suburban apartment house. Like most translators, I am quite accustomed to living in similar circumstances in Japan, so that I was able to have some sense of what this meant, even though it remained a little bit difficult to convey. To be sure, the old superficial differences about the *tatami* floors and the famous *kotatsu* warming device which always seems to require a footnote are still there, and, more to the point, so are the deeper cultural and social differences — the office obligations, the general pattern of human relations. Still, if the translator is challenged by attempting to convey this without writing a treatise along with the translation, he is likely to have had enough personal experience of it to avoid being entirely at the mercy of sociological analysts.

Also, when one is in Japan it is possible, through a kind of osmosis, to have some idea of the general quality of literary activity, or at least of its decibel level. One knows something of what authors are doing, even without reading newspapers and watching television. From the subway ads for the weeklies alone you can learn about the latest literary prizes or polemics in the literary world, and especially about scandals which as every student of the *I*-novel knows are highly significant in Japanese literary affairs.

Among the mechanisms which help to facilitate selection, then, are the very many literary prizes awarded in Japan. One might say there are too many. No doubt we have far too few in this country, but those in Japan are sometimes rather bizarre, and in any case they do not necessarily seem to isolate the kinds of works which readily yield to the blandishments of the translator.

Again, literary journalism in Japan is often hard to decode. It tends to be either exceedingly discreet and uninformative or so cliquish that one learns from the review chiefly whether the author is inside or outside the camp of the particular writer involved. The criticism of a more reflective kind

which comes along later is, as sociology has been alleged to be, a kind of slow journalism that perpetuates some of these same weaknesses.

So I suppose the chief mechanism for selection or bottleneck, if you will, remains the translator. On rare occasions translations are commissioned, and this raises questions as to the editorial wisdom available to publishers, and to committees or other sponsors, a matter that we should probably set aside for later discussion.

At first glance, however, there now appears to exist a rather impressive representation in English of modern Japanese fiction, if not of what we might call contemporary fiction. (The latest bibliography from the International House of Japan suggests that there might have been an even larger representation in the Chinese language, had it not been for the political turmoil of twentieth-century China.) But among later writings and even those of the earlier Shōwa period, there are some fairly appalling gaps. One might expect that Tanizaki Jun'ichirō who is regarded by many as the greatest of modern Japanese novelists, would be the most fully revealed in translation, and yet there is a very important early novel of his, *Chijin no ai (A Fool's Love)* which has been widely translated throughout the world, once into Russian and twice into Chinese[1] — in Shanghai shortly after it appeared and more recently in Taipei — and which has never been given to us in English. And this is a novel in the mainstream of realism, not difficult to translate, except as everything is difficult. Then there is another fascinating novel by Tanizaki called *Manji*, a title that has been rendered in a bibliographical entry as "The Fylfot." This device is a kind of Buddhist reverse swastika symbolizing an emotional vortex, or "whirlpool," a translation that Tanizaki is said to have disliked. But not even such a title is untranslatable. It simply awaits translation, and perhaps some day a resourceful translator or an editor like Harold Strauss will find an appropriate translation for it, just as Tanizaki's *Thin Snow (Sasameyuki)* was transformed into *The Makioka Sisters*.[2] To be sure, there can hardly be any such instant solution to the chief difficulty with *Manji*, the question of narrative voice for a novel which is told throughout in the voice of an upper-class Osaka woman, in an elegant and yet somehow very earthy dialect. Of course, there are many other untranslated stories and novellas by Tanizaki that one might mention, since the shorter forms are particularly difficult to publish in English.

Yet it is true that few Japanese novelists have been so well known abroad. Among eminent living writers, I think for instance of Ishikawa Jun, now eighty years old, a brilliant stylist not only in his many essays and short stories but in several major novels. In 1961 Donald Keene translated Ishikawa's novella *Asters (Shion monogatari)*. This was followed modestly four years later by an Italian version;[3] since then, utter silence. Then there are the many fine younger writers who have never been translated at all.

I could probably draw up a considerable list of those I should not have omitted from the anthology of contemporary Japanese literature which I compiled a few years ago. Some were completely overlooked, others were undervalued, and there were also a few whom I particularly wanted to include but found difficult either to translate myself or to match with a good translator. One of these, for instance, is Shimao Toshio. I had attempted to interest several translators in Shimao's work, and indeed sent off some books of my own to them, only to be told much later that the attempt at matchmaking was unsuccessful.

Inevitably one comes to the question of how the translator will find the right work, but it seems impossible to answer this question for someone else. One can only mention writers one likes, or list important works that have not yet been done. The question of whether they suit the tastes and talents of the particular translator is something else again. The translator must simply read a great deal and seek an affinity wherever it may be found. Unfortunately, sometimes in the course of translation, perhaps more often than not, this affinity begins to wear rather thin.

Naturally the faculty of critical judgment has to be exercised throughout the work of translation, not only in the gross, in selecting what to translate, establishing the tone, and so on, but down to the very last word, and beyond it, so long as any editorial attentions are being brought to bear. I believe that even the most skillful editor, if he cannot constantly go back to the original text, is only able to smooth out something that was probably rather flat to begin with, much as an ancient phonograph record might be reprocessed in an attempt to make it suitable for a modern high fidelity stereo system. The result is likely to be insipid. A good translator tries, and necessarily fails, to keep all the elements — the timbres, the harmonies, the rhythms, the nuances, and so on. Trying to follow this counsel of perfection, however, is bound to be arduous. No matter what the details of the methods employed (and no two people work in quite the same way), surely there is always at least a going back and forth between the Japanese text and the English; then too there must be within

"Making her toilet." Takehisa Yumeji, 1908.

the translated version a going back and forth from the detail to the whole to grasp the whole, in order to get the detail right, if there is to be any chance of success.

Obviously, complete bilingual virtuosity would be a decided advantage in this, and one envies the gifted linguist Y. R. Chao, for example, who was able to translate into Chinese the charming nonsense verse of Lewis Carroll and then translate it from Chinese back into the English, without spilling a drop. Dr. Chao asserted that this was the best test of one's translating powers: that is, to translate something, leave it aside for a time, and then translate it back and see if it is identical with the original. Perhaps this is the sort of test everyone should be asked to pass before receiving a certificate as a translator, which would certainly thin the ranks considerably.

It so happens that my own teacher Serge Elisséeff practiced this method with Sōseki during the Meiji era, and he did it simply to train himself in the Edo style of language that was seen so beautifully in Sōseki's dialogue. He would translate a passage from one of Sōseki's novels into Russian or French, and then after a time return to his translation and translate it back into Japanese, to see if this version and the original were exactly the same, or, if not, why not. I am afraid, to close on a somewhat lighter note, that the results of such an experiment would usually be closer to those of the experiment carried out by the scientifically indefatigable Edward S. Morse and recorded in his book *Japan Day by Day*:

> I asked a Japanese to translate "pease porridge hot" into Japanese, writing the Chinese characters in their method of syntax; then I showed this to another Japanese and asked him kindly to translate it into English, and got the following:
> Pea juice is warm
> And cold and in bottle
> And has already been
> Nine days old.[4]

Notes

1. Tanizaki Jun'ichirō, *Liubov' gluptsa*, trans. G. S. Immerman (Leningrad: Priboi, 1929).

——— *Ch'ih jen chih ai*, trans. Yang Sao (Shanghai: Pei hsin shu chü, 1928).

——— *Ch'ih jen chih ai*, trans. Ch'iu Su-chen (Taipei: Shui niu chü pan she, 1972).

An English translation was finally published in the fall of 1985 as *Naomi*:

——— *Naomi*, trans. Anthony E. Chambers (New York: Knopf, 1985).

2. Tanizaki Jun'ichirō, *The Makioka Sisters*, trans. Edward G. Seidensticker (New York: Knopf, 1957).

3. Ishikawa Jun, "Asters," in *The Old Woman, The Wife, and The Archer. Three Modern Japanese Short Novels*, ed. and trans. Donald Keene (New York: Viking Press, 1961), pp. 119–172.

———"La storia delle settembrine," trans. Atsuko Ricca Suga, in *Narratori giapponesi moderni* (Milano: Bompiani, 1965), pp. 647–698.

4. Edward S. Morse, *Japan Day by Day* (Boston and New York: Houghton Mifflin Co., 1917), 1:369.

A Waitress. Takehisa Yumeji, 1909.

THOUGHTS ON JAPANESE
TRANSLATION AS IT IS PRACTICED
by Phyllis I. Lyons

Phyllis I. Lyons has been a literary critic since her under-graduate days at the University of Rochester; her special interest in Japanese literature came during her graduate study at the University of Chicago and Keio University in Tokyo. The translations in her book *The Saga of Dazai Osamu: A Critical Study with Translations* (Stanford University Press, 1985) won the 1983 Japan-U.S. Friendship Translation Prize. At present she teaches comparative literature and the Japanese language at Northwestern University.

Miss Lyons's essay emphasizes the art of reading itself as a form of "translation" from author to reader and indicates some of the transformations required to move the realities of Japanese culture into the English language.

My purpose here is not to convey new information, but to step back for a moment and speak in more general terms of "what we're about," as readers, translators, and critics; not to offer new insights but to remind us of some considerations we take into account when we think of translation: what we expect; what we get; and what we dream of.

To begin with, we may consider the matter of "what we expect" when we read a translation.

I hope you will pardon this rather simplistic, mildly Platonic formulation of what happens in translation, but obviously, the first step is when an idea is "translated" from the mind of a writer, to paper. The second step is the translation of the written text to the mind of the reader (and, as a teacher, I can say that the blankness that is occasionally the class response to a given written text suggests that this stage of translation is a difficult one, and is sometimes never made). The translation of which we are speaking here is only the third stage, when the reader who has been a receiver becomes a donor, and creates a new written text which, one hopes, is closely related to the first text.

Reading itself is thus an act of interpretation, of translation. And this translation need not even involve a foreign language. George Steiner reminds us that "any thorough reading of a text out of the past of one's own language and literature is a manifold act of interpretation."[1] Masao Miyoshi carries the caution a step further, speaking of the *Genji mono-gatari*, annotated in Japanese for Japanese readers: "Even punctuation is an act of interpretation."[2] And we know that even at the first stage between the first mind and the first piece of paper, the relationship is difficult — as a writer's revisions amply show. The text is only an approximation of an idea.

Given the difficulty of the enterprise, we might wish to abandon in despair the idea of translating from one language to another. But of course, we do not. Hence, we have "what we expect": a reasonable facsimile of something that might have been said in our own language, if not by someone of our own culture.

There is an implied debate between critics (and every reader is a critic) concerning this "reasonable facsimile." To set aside the issue of *mistranslation*, on which all parties agree, we might say that most of us at heart belong to the "soft line" party: a given translation may not be exactly "living language," but the facsimile is generally reasonable; and at least nonreaders of that language have something, even if

it is awkward, that would be otherwise unavailable. And, of course, an author may even be well served. With a good translation, we have the possibility of an amazing and improbable event: a group of Swedish readers may award the Nobel Prize to the writer of a language none of them reads.

The "hard line" party aims only for the good translation, to the exclusion of others: if it does not read as well as the original does, then strangers are better off not knowing about it, rather than wasting their time and maybe suspecting the contributing culture is trivial and inferior as a result of the translation.

The soft liners are numerically superior, undoubtedly, and so is the number of undistinguished translations. Perhaps the majority of readers never notice the difference, as they read passively, not missing stylistic integrity so long as the story holds them. Additionally, a literature like Japanese may even be treated to an "exoticism handicap": many readers *expect* it to sound a little weird. (I do not here address the question of translation of works which are, in fact, awkward in the original but which should be and are translated for, say, extraliterary reasons.)

With a recognition that our standards themselves are variable, we may look next at "what we get," with some speculations and miscellaneous observations.

The Japanese language and the internal expectations of Japanese literature are the first problems we face. Whether or not one agrees with Roy A. Miller's postulation of an attitude of mysticism on the part of Japanese toward their own language,[3] it is true that Japanese have special feelings toward the possibilities of their language and its relation to life and art, and these feelings have an effect on what Japanese writers write about and how they write. Many of the special language relationships are not immediately available to non-Japanese (which is only to say that the Japanese language, like every other, has some unique features). For example, in my own work on Dazai Osamu, I have found how close to a sense of the rhythms of spoken Japanese his writing is, and how hard that is to duplicate in English. Judas's cackling hysterically, "Heh, heh, heh" (in *Kakekomi uttae*), or the coy poutings of a schoolgirl (in *Joseito*) have what Masao Miyoshi has called, in *Accomplices of Silence*, an "embarassing" quality.[4] It is, however, the embarrassment of recognition that the reader of Japanese feels. These moments simply do not work in English.

Even the orthography of written Japanese is a resource not open to us. Tanizaki Jun'ichirō who elsewhere laments the poverty of "indigenous" Japanese vocabulary (a subject Professor Miller addresses in his above-cited monograph), writes in *Bunshō tokuhon* of the contribution to literary effect — to "meaning," if you will — made simply by the way a Japanese author chooses to "spell" a word. In Shiga Naoya's *Kinosaki nite*, for example, says Tanizaki, the onomatopoetic *bu--n to* with which a honey bee takes flight has different feeling for having been written in *hiragana* instead of *katakana*.[5] I read, and I am convinced. Arishima Takeo uses onomatopoetic words in his children's story *Hitofusa no budō*, and the effect is not one of baby talk, but a gentleness and intimacy that automatically pulls the adult reader into the world of childhood fears, tragedies, and consolations, memories of which lie close under the surface of every adult psyche.

This, of course, is hard to reproduce in translation, although translators labor hard to do so. George Steiner speaks of an "intentional strangeness," a "creative dislocation," that sometimes is invoked in the attempt.[6] He cites Chateaubriand's 1836 translation of Milton's *Paradise Lost*, for which Chateaubriand "created" a Latinate French to approximate Milton's special English as an example of just such a successful act of creation. He also speaks of what he calls the " 'moon in pond like blossom weary' school of instant exotica," of which we are perhaps all too familiar.

Like the poor, the problem of language is always with us in "what we get." Beyond that is the issue of selection. There is a quality or arbitrariness to what gets translated, both in terms of works and of writers, and of course, this does not just apply to translations from the Japanese.

Let us now look at translations of Natsume Sōseki's works. Everyone agrees that he is one of the most important of modern writers, and that his novels may have a certain sequentiality, as a consequence of having been written in chronological time. Yet, to speak only of three novels written between 1908 and 1910 (sometimes treated in Japanese criticism as his "first trilogy"), the third of them, *Mon*, appeared in translation first (in 1972), the first, *Sanshirō*, appeared second (in 1977), and the second, *Sorekara*, was last of all (*And Then*, in 1978). And all three were much preceded in translation by two later novels, themselves translated "out of order": *Kokoro* (1914, translation in 1957) and *Kōjin* (1912, *The Wayfarer*, in 1967). "How," I was asked recently by a student alert enough to realize that he was reading in translation, and despairing of the significance of that fact, "can you say *anything* about the growth of the writer's mind and style, much less the development of his language, when

there's no sense of continuity to any of this, and they all sound different," as a result of each having been translated by a different translator?

In the choice of writers, too, there often seems to be no relation between Japanese judgments and Western. Mishima Yukio was, by the end of his life, perhaps more popular in the West than he was in Japan. Even before his death, it was being noted by some that he seemed to be writing for a Western audience. Marleigh Ryan, in a review of Mishima's final tetralogy, notes that the "intellectual frame" on which Mishima pinned his hopes for *The Sea of Fertility* comes down to "simplistic essays on Buddhism, Hinduism, and even one protracted discourse on reincarnation in Western philosophy, all resembling nothing so much as excerpts from an inept graduate student's term paper."[7] Yet the thousands of words explicating its "deep philosophical significance" in the Western press make one sigh. *Shogun* is a rip-roaring attention holder, but no one pretends it is great literature. Mishima did not always even hold one's attention, at the end. His genuine accomplishments are not to be denied — I think *Kamen no kokuhaku* (*Confessions of a Mask*) is one of the saddest and most magnetic books in modern Japanese; but is it not possible that Mishima made such an impression here because he gave us what we wanted: a "philosophical" *and* flamboyant Japanese?

Mishima had harsh things to say about Japan's translation-mill style of making foreign works available; and, as one might expect of a man vitally interested in being translated, he was most laudatory about what he felt to be the Western attitude toward translation: "I know from personal experience how strongly foreign publishers and readers demand excellence in English prose style in their translations."[8] The degree of his faith is touching.

For in fact, as another aspect of "what we get," we can say that our translations too are highly uneven, and criticism of them and of the quality and significance of the original works has often a feast-or-famine aura to it — extravagant praise or iconoclastic attack.

Things translated are not uniformly great, and their writers are not uniformly important. We must be careful of the emperor's new clothes, not to imagine them richer than they are, both original and translation. Nor should we try, in our cleverness, to see them as more inadequate than they are.

Which brings me to my third point, "what we dream of." Robert Frost suggests the task is hopeless: "Poetry is what is lost in translation."[9] All those who write novels, good or bad, are, ipso facto, novelists.

But not all who *translate* novels are novelists. (Mishima castigates those translators who are failed novelists, and who see the prone and helpless body of the work being translated as virgin territory on which to wreak their vengeance.) So we held our universal longing: perfect transference; and the best we can hope for: that lines which are distinguished in their original language will be distinguished in their new incarnation. For good writing has the power to make language live in our minds forever.

In this connection, I should like to say a few words about Arthur Waley and his contribution to those of my generation who first acquired our Japanese through academic training and not through life experience.

It may seem strange to mention *The Tale of Genji* in what is largely a discussion of modern literature. But Waley's *Genji* is part of modern literature. One cannot help but think the 1920s and 1930s an extraordinary time for translation, when Japanese literature seemed almost a part of the mainstream. *Genji* may have been better known in serious reading circles of that day (small and elite though they were) than now in the much larger and decidedly unelite world in which we live.

Proust died in 1922, and Scott Montcrieff was still engaged in his translations of À *la recherche du temps perdu* when Waley began his great project. That Scott Montcrieff went to Shakespeare for his translation title, *The Remembrance of Things Past*, is a step of genius, something akin to Steiner's "creative dislocation," evoking for English readers all that Shakespeare meant, *and* all of Proust (whose own title echoes the French intellectual tradition, following on the premier seventeenth-century Cartesian apologist, Nicolas Malebranche's *De la recherche de la vérité*).

Ivan Morris, in his homage to Waley, speaks of his "rare mastery of style and a self-assurance that allowed him, after he had thoroughly understood a Chinese or Japanese text, to recast it entirely in supple, idiomatic, vibrant English."[10] That this beautiful English prose on occasion did not literally reflect the original text is, I should like to suggest, in the case of Waley's *Genji*, essentially irrelevant, in the following sense.

There is probably not a student of literature who has not stumbled upon "Murasaki's Defense of the Art of Fiction" in Waley's translation, and stopped transfixed. "But I have a theory of my own about what this art of the novel is, and how it came into being." Well, we now know — even those of us who do not read eleventh-century Japanese fluently — that Waley's rendering of this passage is somewhat

ハラダイス
にこ

A Paradise Cafe Waitress at Asakusa in Tokyo. Takehisa Yumeji, 1911.

loose and, through his editing of context, may even be a bit misleading. In the late 1960s and the early 1970s, the passage was debated in print and panel discussions, and a new translation of the complete work reveals it in full context. We know now that Murasaki Shikibu (if she is indeed even the author—ah, the chain of debate is endless) is not necessarily in dialogue with Henry James, although Arthur Waley may have been with Virginia Woolf.

But Waley did call our attention to it; and he fostered in us a certain attitude of serious attention to the author. Who knows, without such "misleading" marquee lights here and there, we might not have seen *The Tale of Genji* for quite the truly extraordinary work it is — in its own tradition *and* ours. Waley did not, I think play the tale and its author false. His lines ring and make the work live for us. That is what we ask of a translation.

Early in my training, when I could not yet read much Japanese, I read the following passage in English in a Western critical study of Natsume Sōseki. This passage alone, in translation, created an image of the novel that carried me through years of struggle to learn enough to be able to read it for myself in the original, and it is one of those passages to which I always draw students' attention, even if in literature-in-translation classes we do not always read the novel *Mon* itself—for it tells us more about Sōseki's concerns, and tells it brilliantly, than a lecture *about* Sōseki's language and "philosophy" could:

> He had come to the gate and asked to have it opened. The bar was on the other side and when he knocked, no one came. He heard a voice saying: "Knocking will do no good. Open it yourself." He stood there and wondered how he could open it. He thought clearly of a plan, but he could not find the strength to put it into effect. . . . He looked behind him at the path that had led him to the gate. He lacked the courage to go back. He then looked at the great gate which would never open for him. He was never meant to pass through it. Nor was he meant to be content until he was allowed to do so. He was, then, one of those unfortunate beings who must stand by the gate, unable to move, and patiently wait for the day to end.[11]

Sometimes even titles have that same ring of felicitous phrasing that stays in our memories, like *The Remembrance of Things Past*. We can forgive Edward Seidensticker's abandonment of poor "Yūgao" (one of the loveliest names in Waley's *Genji*, and nowhere matched by "the Lady of the Evening Faces"), for his having given us *Some Prefer Nettles* (Tanizaki's *Tade kuu mushi*) and *In Praise of Shad-*

ows (the same author's *In'ei raisan*). As these examples show, while not all translators are writers, enough are, enough of the time, that we continue to dream and hope.

In conclusion, I would like to reiterate what translation is finally *for:* to give us something we might not otherwise have. It is for the purpose of communication, and education, and entertainment, and consolation, all this and more. But mainly, it is so we can continue to read literature, for whatever purpose — a great deal of it, from all over the world.

I end with another of my favorite passages of translation, for no other purpose than to show what would not be available for nonreaders of Japanese otherwise. It is a "grabber," and I always use it in my classes. Some listeners are repelled, others amused, others puzzled — but none is unmoved. It is perverse, comic, serious, and sad, all at the same moment, and reminds us again to be grateful for the work of translators of Japanese literature:

> In this life I have been blindly in love with Satsuko, but after death, supposing I bear any malice toward her, I shall have no other means of revenge. Possibly I may not have the least will to revenge once I'm dead. Somehow I can't believe that. Although it stands to reason that the will dies with the body, there may be exceptions. For example, say that part of my will survives within her will. When she treads on my grave and feels as if she's trampling on that doting old man's bones, my spirit will still be alive, feeling the whole weight of her body, feeling pain, feeling the fine-grained velvety smoothness of the soles of her feet. Even after I'm dead I'll be aware of that. I can't believe I won't. In the same way, Satsuko will be aware of the presence of my spirit, joyfully enduring her weight. Perhaps she may even hear my charred bones rattling together, chuckling, moaning, creaking. And that would by no means occur only when she was actually stepping on my grave. At the very thought of [my "Buddha's Footprints" gravestone] modeled after her own feet she would hear my bones wailing under the stone. Between sobs I would scream: "It hurts! It hurts! . . . Even though it hurts, I'm happy — I've never been more happy. I'm much, much happier than when I was alive! . . . Trample harder! Harder!"[12]

61

Notes

1. George Steiner, *After Babel: Aspects of Language and Translation* (London and New York: Oxford University Press, 1975), p. 17.

2. Masao Miyoshi, "Translation as Interpretation," *Journal of Asian Studies*, 38:2 (1979):300.

3. Roy Andrew Miller, *The Japanese Language in Contemporary Japan: Some Sociolinguistic Observations* (Washington: American Enterprise Institute for Public Policy Research, 1977).

4. Masao Miyoshi, *Accomplices of Silence* (Berkeley: University of California Press, 1974).

5. Japanese syllabary letters *(kana)* are written in two forms, viz., *hiragana* ("Cursive") and *katakana* ("Square"). See Tanizaki Jun'ichirō, *Bunshō tokuhon* (Tokyo: Rokkō Shuppan, 1973), pp. 29-30.

6. Steiner, *After Babel*, pp. 316 ff.

7. Marleigh Ryan, "The Mishama Tetralogy," *Journal of Japanese Studies*, 1:1 (1974): 169.

8. Mishima Yuko, *Bunshō tokuhon* (Tokyo: Chūō Kōron sha, 1959; 1969 ed.), p. 108.

9. Louis Untermeyer, *Robert Frost: A Look Backward; A Lecture . . .* (Washington: Library of Congress, 1964), p. 18.

10. Ivan Morris, ed. *Madly Singing in the Mountains: An Appreciation and Anthology of Arthur Waley* (New York: Harper and Row, 1970), p. 71.

11. Edwin McClellan, *Two Japanese Novelists: Sōseki and Tōson* (Tokyo: C. E. Tuttle, 1971), p. 45.

12. Tanizaki, Jun'ichirō, *Diary of a Mad Old Man*, trans. Howard Hibbett (New York: Berkley Publishing Corp., 1965; 1971 ed.), pp. 126–127.

TRANSLATING POETRY

TRANSLATION AS ART
by Harold Wright

Harold Wright teaches Japanese language, history, literature, and the translation of poetry at Antioch College. He received graduate training at the University of Hawaii, Columbia University, and Keio University in Tokyo. Among his translations are a collection of poems by the Emperor Meiji, the Empress Shoken, and a selection of lyrics from the *May'yōshū*, the great early collection of Japanese poetry. He has also translated a number of contemporary poets, notably Tanikawa Shuntarō.

In his essay, Mr. Wright discusses the difficult choices that the translator must make between free and literal versions of his texts, a particular problem, as he sees it, when rendering into English modern and contemporary Japanese poetry.

国技館にて

Sumo Spectators. Takehisa Yumeji, 1911.

 A number of years ago several of our Japanese-related journals carried an ongoing debate on the art or techniques of translating the prose literature of Japan. Some of these manifestos and arguments often degenerated into a subtle, or not so subtle, academic name calling. But two distinct groups did emerge. One was called, by the other perhaps, the "literalists" (those who strove as much as possible to remain faithful to the original syntax), and the other side was branded as the "libertines" (those who moved away from the original syntax in an attempt, they felt, to present the reading public a work in English that conformed to their own standards of literature).

But we are dealing with poetry today, and not much written material has entered the journals in the way of academic argument. There are, however, probably two or three hundred books on the market or in libraries today that present collections of Japanese poetry in English translation. These books range from Peter Pauper Press collections of *haiku* to published dissertations on specific poets or works of poetry. Many of these books contain, in the preface or introductions, some statement of the translator's view of translation. By looking at both the statements of the compilers and at the translations themselves, we find it relatively easy to apply the "literalist/libertine" models to a number of the collections. But for the most part, they seem to fall in the middle of the road. Most translators of poetry attempt to remain faithful to both the original poetry and their own views of English language verse. Yet faithfulness in any human endeavor can be a relative thing. One person's view of English-language poetry may be limited to rhyme or even to thumping couplets of iambic pentameter. Another translator may insist upon rendering even the most structured poem in the original in free verse statements. Let us look at a few translations of a single well-known *haiku*. Matsuo Bashō's (1644–1694) famous frog poem reads in Japanese as:

> *Furuike ya*
> *kawazu tobikomu*
> *mizu no oto*

This has been translated in a number of ways:

> The old pond;
> A frog jumps in, —
> The sound of the water.[1]

> old pond —
> and a frog-jump-in
> water sound.[2]

The old pond aye! and the sound of a frog leaping into the water.[3]

> Into the calm old lake
> A frog with flying leap goes plop!
> The peaceful hush to break.[4]

> The old pond!
> A frog lept into —
> List, the water sound![5]

A lonely pond in age-old stillness sleeps . . .
> Apart, unstirred by sound or motion . . .
till
Suddenly into it a lithe frog leaps.[6]

> Into an old pond
> A frog took a sudden plunge,
> Then is heard a splash.[7]

> Old garden lake!
> The frog thy depth doth seek,
> And sleeping echoes wake.[8]

> An ancient pond!
> A frog leaps in;
> The sound of the water![9]

An old-time pond, from off whose shadowed depth
Is heard the splash where some lithe frog leaps in.[10]

> The ancient pond,
> A frog has plunged —
> Splash![11]

> OLD DARK SLEEPY POOL . . .
> QUICK UNEXPECTED
> FROG
> GOES PLOP! WATERSPLASH![12]

> AN OLD SILENT POND
> INTO THE POND
> A FROG JUMPS
> SPLASH! SILENCE AGAIN.[13]

> An old pond —
> The sound
> Of a diving frog.[14]

The old green pond is silent; hear the hop
Of a frog plumbs the evening stillness: plup![15]

> An old pond
> A frog jumps in —
> Sound of water[16]

> old pond
> a frog in-leaping
> waternote[17]

> The old pond —
> A frog leaps in,
> And a splash.[18]

> mossy pond;
> frog leaping in —
> splash![19]

When the old pond
 Get a new frog
It's a new pond.[20]
". . . to express the concept of satori."

 The bungling frog
 Leaped for the pond, but landed
 in Bashō's brain.[21]
"translated as a Zen *koan*."

But let me become more personal and speak of my own views of translation. In the two decades or so that I have been involved with the translation of Japanese poetry, I have found myself evolving slowly from the libertine position to the attitude of the literalist. I am not quite all the way yet. The logical conclusion of the literalist movement, I believe, would be pidgin English, and I hope that I have not gone quite that far. But as I now view my earliest attempts at translation, I find that my more libertine views were not based so much on any kind of philosophical or literary argument, but simply on a lack of skill. Not that I was ever one of the worst of the libertines. Since Japanese poetry does not rhyme, I did not add rhymes. I did not add a lot of my own adjectives to a translation thinking the poem would be considered too stark without them. I did not add passages of my own poetry to my translations in hopes of improving a good thing. I did not repeat one or two "good" lines over and over in an attempt to give a translation some kind of refrain that did not exist in the original. I did not take a highly structured poem like the *haiku* and expand it into four, five, or six lines of Victorian or even free verse.

In the early 1960s I translated and published a lot of Hagiwara Sakutarō, one of the founding fathers of modern Japanese poetry. I presently prefer Hiroaki Satō's versions to my own older ones. Hagiwara Sakutarō often worked in long flowing lines of free verse. an example would be:

> *Aogeba takaki matsu ga eda ni koto kakenarasu.*

A single line that could be translated something like:

> Gazing up I see a koto being played in high pine branches.

Of course, I have added the personal pronoun "I" to this line since the verb *aogeba* (looking or gazing up) has no subject in the original. I have taken some liberties with the *matsu ga eda* by rendering it as "pine branches" since there is no indication as to number in the original, as is the usual case with most Japanese nouns. But in the earlier years of my career, I had difficulty in maintaining any sort of rhythm in such a long line. I found it easier to break long flowing lines into shorter choppier ones. So

consequently, one of my earlier translations was published as:

> Looking up I see
> In the high branches of a pine tree
> A lute that's being played.

(I see that I have taken liberties, too, with that marvelous Japanese koto and magically turned it into a lute.) But I am no longer very happy with my choppy unfaithfulness. Throughout the sixties, however, this lack of fidelity was rewarded in a strange way. Shortly after I began publishing such translations in literary magazines and journals, I found that I was being paid *by the line*. Oh, sometimes as much as fifty cents or one dollar a line. Weakness or not, I found that I could get maybe twelve dollars out of an eight-line poem in the original. More than one bottle of sake was purchased out of a stretched out poem of Hagiwara Sakutarō. (But I feel *he* would have understood.)

All in all, I have found no ideal solution to the literalist/libertine problems confronting the translation of Japanese poetry. I stress in my translation classes at Antioch that translations of poems are basically opinions: the first opinion involves the original poem (What do I think this poem is all about anyway?), and the second opinion involves a personal aesthetic judgment as to what that poem should look or sound like in English. I try to be both literal and poetic (according to my ear anyway) at the same time. But being faithful to two principles is like being faithful to two lovers. At any one moment, you are bound to be a little too close to one side to suit the other. It is a case of being damned if you do and damned if you don't. The scholars always complain that you are too far removed. The poets nag you about lack of affection.

Over the years I have always attempted to develop rules (for myself anyway) governing the art of translating poetry, but few, if any, of my rules have fit all cases, so I often throw out the rules and play it by ear. I do, however, have several guidelines that I follow, for the most part:

1. I attempt to totally understand the original poem. Now this may seem like a silly guideline. "Of course," you may say, but remember that a number of the "best-selling" translators of Japanese poetry do not read a word of the Japanese language. These poets work for the most part from literal drafts provided by Japanese scholars. But I read a poem over and over until I feel that I have actually gotten inside the poem from a Japanese

Museum in the Evening Takehisa Yumeji, 1913.

point of view. If something is fuzzy for me, I ask a native speaker, preferably the poet himself or herself if I happen to be in Japan. This does not always help, however. Once when discussing a difficult line with Tamura Tyuichi, he looked at me puzzled and said, "I thought I knew what that line meant when I wrote it, but I don't understand it myself now." Also, I ask poets like Tanikawa Shuntarō to tape readings of their poetry for me. This aids me greatly in trying to establish moods, nuances, and rhythms of the original poem.

2. I never add any more to a poem than is absolutely necessary to make sense in English. I add subjects to verbs, for example.

3. I try to follow the original line order when translating any poem. The poet had a reason for presenting the images of a poem in a certain order, and I try to respect that order. It is much harder, of course, to try to repeat the word order in a given line due to the S.O.V. (Subject, Object, and Verb) syntax of the Japanese language as opposed to the S.V.O. structure of English. But I do try to keep the line order intact. Some poems, especially the more traditional forms like the *haiku*, are, in structure, similar to jokes. You just do not give away the punch line early when telling a joke, and it is not good to give the last line away in translating poetry either.

4. This guideline is used only when working with traditional verse forms. It deals with syllabics. When I translate a seventeen-syllable *haiku* or a thirty-one-syllable *tanka*, I try to capture the original syllables of the poem. I say try. This is something akin to trying to work international crossword puzzles, and I find myself rather harmlessly elated when I get one to work, or nearly work. A number of my *tanka* translations have four- or eight-syllable lines rather than the perfect five or seven. Take one of my translations from the *Man'yōshū*:

> To love someone
> who does not return that love
> is like offering prayers
> Back behind a starving god
> within a Buddhist temple.[22]

This poem has the required thirty-one syllables, as does the original, but the first line in my translation has merely four, and the third line has, according to my count, six. To be a perfect syllabic translation, each of these lines should have five syllables. But I say this is close enough. To get it any closer I would have to take away a number of things I do like in the poem. Anyway, from this translation you can see that the original poem as a *tanka* and that Lady Kasa was not, as others may lead us to believe, writing either free verse or iambic pentameter in eighth-century Japan.

Notes

1. R. H. Blyth, *Japanese Life and Character in Senryu* (Tokyo: Hokuseido, 1960).
2. Harold G. Henderson, *An Introduction to Haiku: An Anthology of Poems and Poets from Bashō to Shiki* (Garden City, N.Y.: Doubleday, 1958).
3. Basil Hall Chamberlain, *Japanese Poetry* (London: John Murray, 1911).
4. William N. Porter, *A Year of Japanese Epigrams* (Oxford: Oxford University Press, 1911).
5. Yone Noguchi, *The Spirit of Japanese Poetry*, Wisdom of the East Series (London: J. Murray, 1914).
6. Curtis Hidden Page, *Japanese Poetry: An Historical Essay with Two Hundred and Thirty Translations* (Boston and New York: Houghton Mifflin, 1923).
7. Asataro Miyamori, comp. and trans., *An Anthology of Haiku Ancient and Modern* (Tokyo: Maruzen, 1932), p. 132. As translated by Inazō Nitobe.
8. Ibid. As translated by Hidesaburō Saitō.
9. Ibid. As translated by Minoru Toyoda.
10. Ibid., p. 133. As translated by Clara A. Walsh.
11. Ibid., p. 130. As translated by A. Miyamori.
12. *Japanese Haiku: Three Hundred and Thirty Examples of Seventeen-Syllable Poems by Basho, Buson, Issa, Shiki, Sokan, Kikaku, Ransetsu, Joso, Yaha, Boncho, and others*, in New Translation (Mount Vernon, N.Y.: Peter Pauper Press, 1956).
13. Peter Beilinson and Harry Behn, *Haiku Harvest* (Mount Vernon, N.Y.: Peter Pauper Press, 1962).

14. Kenneth Rexroth, *One-hundred Poems from the Japanese* (New York: New Directions, 1964).

15. Harold Stewart, *A Net of Fireflies: Japanese Haiku and Haiku Paintings with Verse Translations and an Essay* (Tokyo: Tuttle, 1960).

16. Geoffrey Bownas and Anthony Twaite, eds. and trans., *The Penguin Book of Japanese Verse* (Baltimore: Penguin Books, 1964).

17. Maeda Cana, *Monkey's Raincoat* (Tokyo: Mushinsha, 1973).

18. Makoto Ueda, *Matsuo Bashō*, *Twayne's World Author Series* (New York: Twayne, 1973).

19. William Howard Cohen, comp., *To Walk in Seasons: An Introduction to Haiku . . .* (Rutland, Vt.: Tuttle, 1972).

20. Ibid.

21. Ibid.

22. Harold Wright, trans., *Ten-Thousand Leaves: Love Poems from the Manyōshū* (Boulder: Shambhala, 1979).

THE TRANSLATOR AND HIS MATERIAL
by Hiroaki Sato

Hiroaki Sato's anthology of Japanese poetry with Burton Watson, *From the Country of Eight Islands*, won the P.E.N. Translation Prize for 1982. His numerous translations of Japanese poetry range from the earliest period through contemporary experimental verse. He writes a biweekly column, "Here and Now—in New York" for the *Mainichi Daily News*, Tokyo, and a monthly column in *Hon'yaku no sekai (The World of the Translator)*, a monthly magazine published in Tokyo.

Mr. Sato's paper recounts some of his own experiences in translating into English and publishing the work of a variety of modern Japanese poets.

My subject is how I choose poets and poems for translation. But first, I would like to point out two things.

One is that I translate into an acquired language, English. This means that I must have collaborators. I have been exceptionally fortunate in having kindhearted, patient, and gifted persons to help me. Nevertheless, I keep in mind Prof. Donald Keene's conviction that collaboration "can never be as good an arrangement as a single translator who himself experiences the original, and who summons up from his store of English words the right equivalents."[1]

The other is that I make my living partly by translating nonliterary works. This has generated in me a considerable amount of impudence and imprudence and I tend not to be as discriminating in selecting poets and poems as someone working on poetry might be.

The choice of poets and poems for translation is largely determined by the translator's purpose. I began translating poems as a graduate student. At first, I evidently had no clear purpose, for if I made any selections I do not remember them. As I recall, I made my first conscious choice for translation when I fell in love. The poet I selected was Takamura Kōtarō (1883–1956), and the work that I chose to translate, *Chieko shō*, included a group of poems about his wife, who became insane. Not that I wanted my lover to lose her mind; the determining factor was indisputably my expectation that by translating this well-known book of love poems I might articulate what I may not have felt. I am probably not alone in this sneaky calculation, and I do not think I am either the first or the last Japanese male to pick *Chieko shō* for his English-speaking lover.

After coming to the United States I kept translating, but my selections were haphazard or, if you will, personal, until someone who had just started *Granite*, a magazine in Hanover, New Hampshire, unexpectedly printed a large number of my translations and asked for more.[2] Soon he offered to publish a book for me, and after consultation, it was decided that I would pick ten modern poets and translate ten pages worth of poems for each poet. I set out to choose poets representative of twentieth-century Japan with the help of my brother-in-law, who is a scholar and poet. Through the work on that book, *Ten Japanese Poets*,[3] at least four things emerged as my selection standards. One, I must like the poet. Two, the poet must be comprehensible to me. Three, the poet must be someone who has writ-

Kobe in the Summer. Takehisa Yumeji, 1913.

ten predominantly in the so-called *kōgo*, everyday language, rather than in *bungo*, literary language. Four, the poet must have a certain number of poems that are likely to sound good in English translation.

Probably because translation of modern Japanese poetry is still an unprovocative field of endeavor, these four standards have not caused me much trouble since then, and flippant though it may seem, the fourth one has often proved the most decisive. This may have a good deal to do with the extraordinary luck I have had in finding publishers for individual poets. The comprehensibility of the poet is as important. Modern poets have not gone through natural selection, and to be somewhat cynical, I doubt that it is worthwhile to try to comprehend incomprehensibility in general and a deliberate variety of it in particular in poetry, a branch of literature that many people consider untranslatable in any case. The type of language the poet uses is something one does or does not accept as a criterion. The remaining standard, that of partiality, is a matter of philosophy; the only quality I can pinpoint as something I discriminate against is pretentiousness. Of course, these standards may change as my attitude and circumstances do.

The selection I made for the New Hampshire press remains my choice of modern Japanese poets, with only one or two changes. Since then I have tried to devote a volume to each of the poets. Once a poet is selected, poems seem to choose themselves. In the case of Takamura Kōtarō, for example, I have made a selection from all of his books and included a diary with *haiku* and a selection of fifty *tanka* he dashed off for a magazine,[4] because his poetry appears to become more interesting in light of his life. In contrast, for Hagiwara Sakutarō (1886–1942), I translated only his first two books[5] because they contain his best poems and they show best what he was trying to do. Miyazawa Kenji (1896–1933) wrote a substantial number of poems in *bungo*, which, following my own rule, I did not translate. However, I did translate his *kōgo* poems in *Spring and Asura*.[6]

These three poets — Takamura Kōtarō, Hagiwara Sakutarō, and Miyazawa Kenji — are, by consensus, the three greatest poets of twentieth-century Japan. You run into trouble when you try to decide who is the fourth greatest, and who is the fifth. In the thirty-four-volume Shinchōsha series[7] of modern poets published in the latter half of the sixties, Nishiwaki Junzaburō (1894–1982) and Kaneko Mitsuharu (1895–1975) were not accorded single volumes, while Ishikawa Takuboku (1885–1912) and Muroo Saisei (1889–1962) were. My hunch is that this situation will be reversed when a similar

series is attempted in the eighties, but my brother-in-law may not think so. When it comes to postwar poets, the matter of personal taste becomes pronounced. So far I have worked on three separate volumes on three postwar poets — Takahashi Mutsuo[8] (born 1937), Yoshioka Minoru[9] (born 1919), and Tomioka Taeko[10] (born 1935) — but I am quite sure that some people are upset about this selection.

When I choose a poet for a book, first I get in direct touch with the author or the copyright holder. Copyright holders other than the poets themselves, such as their surviving relatives, tend to complicate things unnecessarily. Luckily, though, most poets are quite flattered to learn that someone has bothered to read what they wrote and give their consent readily, even when they suspect that their particular brand of poetry is untranslatable. Still, there are some exceptions. As far as I know, Nishiwaki Juzaburō (1896–1982) did not mind having a few of his poems translated and published here and there,[11] but he never wanted a substantial selection translated and published in book form. He had planned to do that himself. Speaking of book-publishing, I have learned from experience that one must find out if someone else has done work on a poet recently. Most publishers are unwilling to publish translations of poetry unless they are subsidized, and the few sources for subsidies that exist are reluctant to give money to the same poet twice within a short period of time.

Finally, I would like to say a few things about some modern Japanese poets who may be untranslatable. To make a confession first, two poets I have translated, Takiguchi Shūzō (born 1903) and Yoshioka Minoru, may well belong in this puzzling group of writers. Takiguchi, a genial and shy gentleman who was arrested, imprisoned, and interrogated for advocating surrealism just before the Pacific War, hinted to me that every word and line in his poems is so charged with meaning that translation may be exceedingly difficult. He stopped short of telling me not to render his poems into English because, I suspect, he is a true surrealist. Yoshioka does not agree with people who call him a surrealist, but he did tell me that most of his poems are constructed in such a way that each line modifies the foregoing and following lines. That may not make him totally untranslatable, but nearly so.

In general, I find three groups of poets untranslatable: those who insist that poetry in general, if not their own poetry in particular, is untranslatable; those who play too much with words; and those whose use of allusion is excessive. Of the first group, Andō Tsuguo (born 1919) is a good example. I like

At Yoshiwara, the Geisha District in Tokyo. Takehisa Yumeji, 1913.

his books on Bashō (1644–1694), Buson (1716–1783), and other Edo *haikai* poets,[13] but at every opportunity he lets it be known that he is a student of French poetry and that he considers translation of poetry impossible. Of the second group, Katō Ikuya (born 1929) stands out. Most of his poems are incomprehensible to me, and those select few that I do seem to understand pun heavily. Some of his book titles are also puns, one playing on his own name. I may add that he primarily writes *haiku*. Katō should comfortably belong in the next group as well, but the paragon of this third group is the extraordinary Washisu Shigeo (born 1915). Christened in the Greek Orthodox Church, he was bemedalled in World War II. Among modern poets writing today, he is, I am sure, the only one who reads, alludes to, and quotes from more than ten languages, besides writing traditional *kanshi*, poems in Chinese. Some people will no doubt be able to translate his poems, but I am ignorant, and the mere thought of checking the original of a Greek name, French line, or Persian parable he mentions in his poems is enough to make me wither.

Poets such as Andō, Katō, and Washisu confront us, in an extreme, condensed way, with the question of whether or not poetry can be translated. But that is another story.

Notes

1. Donald Keene, "On Translation," in his *Landscapes and Portraits: Appreciations of Japanese Culture* (London: Martin Secker & Warburg, 1971), p. 326.

2. *Granite: A Journal of Poetry, Fiction, Poetics, and Thought*, no. 2 (Winter 1971–72).

3. Hiroaki Sato, trans., *Ten Japanese Poets* (Hanover, N.H.: Granite Publications, 1973).

4. Takamura Kōtarō, *Chieko and Other Poems*, trans. Hiroaki Sato (Honolulu: University Press of Hawaii, 1980).

5. Hagiwara Sakutarō, *Howling at the Moon: Poems*, trans. Hiroaki Sato (Tokyo: University of Tokyo Press, 1978). Several earlier poems were later translated and included in *From the Country of Eight Islands: An Anthology of Japanese Poetry* (Garden City, N.Y.: Anchor Press/ Doubleday, 1981).

6. Miyazawa Kenji, *Spring and Asura*, trans. Hiroaki Sato (Chicago: Chicago Review Press, 1973).

7. *Nihon shijin zenshū* (Tokyo: Shinchōsha, 1966–68), 34 vols.

8. Takahashi Mutsuo, *Poems of a Penisist*, trans. Hiroaki Sato (Chicago: Chicago Review Press, 1975). A second selection of Takahashi's poems, *A Bunch of Keys*, was published by the Crossing Press in 1984.

9. Yoshioka Minoru, *Lilac Garden: Poems*, trans. Hiroaki Sato (Chicago: Chicago Review Press, 1976).

10. Tomioka Taeko, *See You Soon: Poems*, trans. Hiroaki Sato (Chicago: Chicago Review Press, 1979).

11. As in Hiroaki Sato, trans., *Ten Japanese Poets*, pp. 65–67; and in Alexander Besher, ed., *Anthology of Modern Japanese Poets*, trans. Hiroaki Sato, *Chicago Review* (1973): 67–83. Published as a special issue of *Chicago Review*, vol. 25, no. 2 (1973).

12. Hiroaki Sato, trans., *Ten Japanese Poets*, pp. 40–55.

13. That is, *haiku* (or *haikai*) poets of the Edo period, 1600–1867.

"Journey to the country where is no sorrow." Takehisa Yumeji, 1915.

TRANSLATING CONTEMPORARY JAPANESE POETRY
by J. Thomas Rimer

J. Thomas Rimer is the Chief of the Asian Division at the Library of Congress. He previously taught Japanese literature at Washington University in St. Louis. He has written on both traditional and modern Japanese theater and literature and prepared, with Robert Morrell, a bibliography on Japanese poetry translations available in English.

Dr. Rimer's essay discusses the need for a context on the part of English-speaking readers when approaching translations of modern Japanese poetry.

 As an avid reader, and a very occasional translator, of contemporary Japanese poetry, I must say that the task of genuine comprehension seems a challenging one for both the translator and his reader. There are many specific problems concerned with translation — such as diction, form, level of language, and so forth — that can claim a specialist's undivided attention. The question I wish to raise here, however, is of a different nature, but it seems to me a crucial one. How do we, as foreign readers, come to determine what truly represents contemporary Japanese poetry? What constitutes its range, and what are its accomplishments? And when we read a particular poem by, say, a postwar author, how are we to establish a context in which to appreciate a specific text?

I first came to understand the magnitude of this problem several years ago when Bonnie Crown, who has done so much to further the publication of Asian literature in English, asked me to coedit a *Guide to Japanese Poetry*[1] for the Asian Literature Bibliographic Series. Annotating books or studies in translation on the classic *haiku* and *waka* was a fairly straightforward affair, but when it came to modern poetry, the problems were enormous. Most glimpses into postwar or even prewar modern poetry were, and are, for the most part, provided by anthologies which spread before the reader two dozen unfamiliar names and include a few short, and thus perhaps atypical, poems by each. Worse still, the miniglimpses provided by each anthology tend to duplicate themselves, with the same text worked over and over again by various translators. One case in point can be illustrated by a poem of the fearfully difficult and, to me, highly stimulating Nishiwaki Junzaburō (1896–1982), whose early work was much affected by his trips to England and France.

He returned to Japan writing a kind of surrealist verse, totally at odds with both traditional poetry and the kind of "modern" verse being produced in Japan in the 1920s and 1930s. This much the introductions to the various anthologies tell us, but most of them timidly go on to repeat the same few poems. One in particular is constantly repeated, possibly because it is one of the shortest — and easiest — from his 1933 anthology *Ambarvalia*.[2] At least the poem seems the same: yet listen to how differently it comes out in the hands of four translators.

RAIN

The south wind brought with it the soft goddesses.
It moistened the bronze, it moistened a fountain,
It moistened the wings of sparrows and feathers of
 gold,
It moistened the tide, the sand, the fish,
It moistened the cathedral, the public bath, and the
 theatre quietly;
This parade of quiet goddesses
Moistened my tongue.

> Kōno and Fukuda,
> *Modern Japanese Poetry*[3]

With the south wind a gentle goddess came.
She soaked the bronze, she soaked the fountain,
She soaked the sparrow's belly and its feathers of
 gold,
She hugged the tide, lapped the sand, drank the
 fish.
Secretly she soaked the temple, the bathhouse, the
 theatre,
The confusion of her platinum lyre —
The tongue of the goddess — secretly
Soaked my tongue.

> Bownas and Thwaite,
> *Penguin Book of Japanese Verse*[4]

A lissom goddess came with the south wind:
She wetted the bronze, wetted the fountain,
Wetted the belly of a swallow, its golden hair;
She embraced the tide, licked the sands, and drank
 the fishes;
She wetted in secret the temples, public baths and
 theatres . . .
And those dishevelled platinum lyre-strings —
The tongues of the goddess —
Softly wetted my tongue . . .

> Ninomiya and Enright,
> *Poetry of Living Japan*[5]

"Enjoying the brightness of the summer sea." Takehisa Yumeji, 1915.

The south wind has brought gentle goddesses,
has wet the bronze, wet fountains,
wet swallows' wings and golden feathers,
wet the brine, the sand, the fish,
wet quietly temples, baths, theaters;
this procession of quiet gentle goddesses
has wet my tongue.

Sato and Watson,
From the Country of Eight Islands[6]

Faced with the kind of divergent aesthetic experiences these translations produce, I soon realized that any single translation of a modern poem can only represent one point of view about an original text and cannot serve as a reproduction of its special virtues. I also became convinced that, when translation is involved, the only way to penetrate into the specific world created by a poet is to be provided with enough of his work so that a reader can make some educated guesses about the poet's enthusiasms, obsessions, verbal patterns, thematic concerns, and so forth. Thus, repetition and reinforcement will help at least to provide a partial replacement for what is inevitably lost in translation. In the past few years, Hiroaki Sato in particular has been doing signal service in giving us volumes of Hagiwara Sakutarō, Miyazawa Kenji, and a number of other important modern poets.[7] From these collections we are gradually coming to comprehend the level of accomplishment of what is, after all, one of the great flowerings of poetry in the world today. Such books generate enthusiasm in their readers, and enthusiasm will hopefully lead us to more knowledge.

Even so, we are still reading without a sense of context. In our own culture, those who read poetry know immediately what kind of work to expect, let us say, from a Charles Olsen, a Frank O'Hara, a Robert Lowell, a James Merril, a Sylvia Plath, or a John Ashbery. The mere mention of the names themselves immediately suggests something of the configurations of literary and philosophic commitment possible within the American literary scene in the past twenty years. We may have a favorite or two among these poets whom we read a great deal, but if we have read any of them, we have surely read something by them all. I would like to suggest that in the mind of an American reader there exists a kind of unarticulated overview, a working definition about the nature of contemporary poetry when approaching the work of any particular modern poet. Along with trying to read and understand the text, the American reader, for better or for worse, will try to fit that poem into a larger framework of contemporary possibilities.

In attempting, as a foreign reader, to get some similar overview of modern Japanese poetry, however, I find the problem to be a very complicated one. There is not, for example, so far as I have been able to determine, a general history of postwar poetry that mentions the whole spectrum of important material. Japanese critics who discourse on the "Wasteland" school, those poets who take after T. S. Eliot, will not deign to mention the political poetry, much of it sardonic and anti-American, that has found such an important place in the postwar literary scene. Those who write on the Japanese experiments in Western forms would not be caught dead discussing contemporary *haiku* and *waka*, of which there are many distinguished practitioners. Indeed it is my suspicion that there may be no real consensus as to who are the "great" modern poets working in Japan today. Thus, trying to compile a useful bibliography or write an essay on the outlines of contemporary Japanese poetry seems, to me at least, to represent an almost impossible task for a foreign reader. I find myself wanting to impose an order that perhaps is not there, so far as Japanese readers of poetry are concerned.

This observation in turn brings me back to the question of enthusiasm. A Japanese poet friend of mine told me, "Don't worry about the overview. Just find a poet whom you like, read him, try to understand him, and don't attempt to make any large-scale judgments." Given the problems most of us have with the kind of difficult and abstract Japanese in which these poets are writing, his suggestion was a rather formidable one, but there is a good deal of sense in what he told me. The real purpose of the poetic act is surely to create a text that can elicit a powerful and true response from a reader. If many such texts succeed, then the poet is a genuine one and perhaps ultimately his place in the literary galaxy is merely sociology. "I feel sorry for poets in your country," my friend went on to tell me, "because they are always worried about earning a national reputation, getting published in major periodicals, and so forth. In Japan, poets tend to write for each other. We participate in groups that are more or less self-sustaining, and our satisfactions come from close contact with others who share our conceptions. National publication helps, of course, but we can survive, spiritually speaking, without it." These are words to ponder. Perhaps Americans spend too much time reading *about* poetry and not enough time with the texts themselves.

Enthusiasm will certainly lead most of us quickly to a certain number of acknowledged masters of modern poetry: I think in particular of Hagiwara

Sakutarō, Miyazawa Kenji, Nishiwaki Junzaburō, and, among younger poets, Tanikawa Shuntarō, Tamura Ryūichi, and, of course, Ooka Makoto. And there are dozens more who could create similarly high levels of enthusiasm if we could only identify them and then read and study selections from their work. Yet even then, the way in which we read them may be quixotic, and our judgments may differ from those of modern Japanese readers. There are a number of areas in which a slippage of perception is possible. For one thing, American readers expect, because of the development of our own tradition, a considerable gap between each generation in the modern movement. We would never confuse, say, Hart Crane with T. S. Eliot, or Robert Frost with Robert Lowell. All of these are "modern" poets, yet we know the interstices within our own culture to such an extent that the differences, not the similarities, constitute our chief impression of their accomplishment. Looking at Japanese poetry, however, since we know the development of the modern movement so imperfectly, we find the similarities and not the differences most apparent, often to the detriment of the individual poet concerned, since his language is invariably flattened out in a transla-

tion. Whether a Japanese modern poem is romantic or hallucinatory, it will seem more like any other modern poem written in English or French than like any poem in the traditional canon of *waka* or *haiku*. We are still struggling towards insight into the modern tradition in Japan, and the bare outlines of the movement from the turn of the century until now which are presently available in English translation do not yet tell us enough.

Then too there is another area of great importance in our learning to enjoy reading modern Japanese poetry in translation. Hiroaki Sato mentions elsewhere the fact that he "discriminates against pretentiousness" in choosing poets and poems to translate. Japan has pretentious poets, just as this country does, and some of them are considered important. But in addition to the judgments made within the same cultural context, there is a particular danger involved when English-speaking readers examine a text in translation that takes some of its own techniques from Western poetry. Let me choose what strikes me as a particularly obvious example. Here is a section of a poem by Tamura Ryūichi called, in Hiroaki Sato's translation, "A Study in Terror":

A Street in Kyoto. Takehisa Yumeji, 1913.

Sometimes
showers will come
or they will accompany thunderclaps as well.
Lightning will pierce the space,
numerous dolphins copulate
and gigantic whales spout rainbows.
Often
the trade wind will be sent to the Ivory Coast
and Henri Rousseau's
dark green trees will flourish.
In the East the stars yet to be named will twinkle
and by the time their light reaches the earth
St John's
John Donne's
Baudelaire's
and Mallarmé's metaphors will be created.
By these metaphors
billions of days and nights part,
millions of days and nights keep harmony
and oh
in my mind
four thousand days and nights engage in battle.[8]

To a western reader, the European references may seem eccentric, even mawkish; the poet seems to be showing off a bit, perhaps. On the other hand, Japanese readers will perhaps find these references exotic in somewhat the way we are excited by the bits of Zen koans, like chocolate chips in ice cream, that flavor the poems of Allen Ginsberg. Whether Ginsberg's offerings would be indigestible for that reason to a Japanese Buddhist, I do not know. In any case, cultural borrowings often tend to look better and more original to the culture that is doing the borrowing than to the culture from which they are borrowed. Just as the Chinese looked suspiciously at the new uses traditional Japanese poets found for Po Chü-i and Tu Fu, so we may feel that contemporary Japanese experimentation only succeeds in reproducing another version of our own. Western readers are seldom given enough in translation to properly answer the question "Does the poet use this technique well, and has he really made it his?" So we render judgments instead, on the basis of a few poems.

For the translator, as well as for those of us who read in translation, then, perhaps the real issue comes back to that simple word "enthusiasm." If the translator finds a modern poet whom he really admires so that, as the great seventeenth-century *haiku* master Matsuo Bashō put it, he can "become one with him," then he will convey his excitement to his reader. I suppose that we should allow such one-to-one relationships to develop and leave aside for the moment any attempt at a hasty overview.

There is much fine poetry being written in Japan now, and as those who translate continue to help us discover it we will begin to grasp the excitement of these times. For the experiments, and the real accomplishments, are many.

Notes

1. J. Thomas Rimer and Robert E. Morrell, *Guide to Japanese Poetry*, The Asian Literature Bibliographic Series (Boston: G. K. Hall, 1975; 2nd ed. rev., 1984).

2. Nishiwaki Junzaburō, *Ambarvalia*, Kokō shishū fukkoku sōsho (Tokyo: Meicho Kankōkai, 1970). Facsimile edition of the first printing of 1933 published by the Shiinokisha, Tokyo.

3. Kōno Ichirō and Fukuda Rikutarō, eds. and trans., *An Anthology of Modern Japanese Poetry* (Tokyo: Kenkyūsha, 1957), p. 104.

4. Geoffrey Bownas and Anthony Thwaite, eds. and trans., *The Penguin Book of Japanese Verse* (Harmondsworth and Baltimore: Penguin Books, 1964), p. 200.

5. Ninomiya Takamichi and D. J. Enright, *The Poetry of Living Japan: An Anthology*, Wisdom of the East Series (London: John Murray, 1957), p. 79.

6. Hiroaki Sato and Burton Watson, trans., *From the Country of Eight Islands: An Anthology of Japanese Poetry* (Garden City, N.Y.: Anchor Press/Doubleday, 1981), p. 507.

7. See the references following Sato's paper on "The Translator and His Material" in this volume.

8. Sato and Watson, *Eight Islands*, p. 558.

TRANSLATING FROM JAPANESE ECONOMIC LITERATURE FOR FOREIGN READERSHIP
by Kazuo Sato

Kazuo Sato has been a professor of economics at Rutgers University since 1984, previously taught at the Institute of Social and Economic Research at Osaka University, and has worked with the U.N. Secretariat in New York. He has published widely in his special fields of interest — economic theory, economic development, international economics, and the Japanese economy. He has been editor of *Japanese Economic Studies* (M.E. Sharpe) since 1972.

Mr. Sato's essay discusses the need for information on Japanese economics to reach English-speaking readers and some of the challenges involved in selecting and publishing appropriate material.

I have been the editor of a quarterly translation journal entitled *Japanese Economic Studies* since its first issue (Fall 1972). Drawing upon this experience, I wish to discuss various aspects of translating from Japanese economic literature for foreign readers. What follow are my personal views rather than any systematic academic discourse on the topic of this symposium. There are a number of aspects of the topic which can be broadly and conveniently distinguished: the inaccessibility of Japanese economic literature to foreign readers, the difficulty of literature searches, selection criteria, translation problems, and financial concerns.

Inaccessibility of Japanese economic literature

Japan has been an economic superpower for some time. In terms of aggregate GNP, Japan has been number two only to the United States among market economies. Japan was even called number one by Ezra Vogel, who insisted that the United States should take lessons from Japan on how to manage its economy.[1] But these lessons are hard to take because, Japan's material success not withstanding, the non-Japanese public knows very little about how the Japanese economy really works.

There are two sides to this sad state of affairs. First of all, there are few qualified specialists on the Japanese economy outside of Japan. For example, how many leading American universities have specialists on their faculties regularly offering courses on the Japanese economy? I do not need two hands to count them. The scarcity of economic experts on Japan does not help the general public improve its understanding of Japan.[2]

At the same time, there has been a significant lack of initiative on the part of the Japanese in making Japanese economic studies by Japanese economists available abroad.[3] The two eminent editors of a massive Brookings Institution volume on the Japanese economy[4] were correct when they opined in their foreword:

> Vast and detailed literature on the Japanese economy does exist, but it is in the Japanese language and well-nigh inaccessible to the

Western world. Consequently, Americans, Europeans, and others interested in understanding one of the most significant developments in postwar economic history have had to rely on translations (often of poor quality), the writings of a few Western specialists, and sketchy newspaper and magazine coverage.[5]

It is well known that there has been a significant imbalance in the exchange of information between Japan and the rest of the world. Japan has been importing foreign publications en masse in the form of translations into Japanese covering a variety of fields. On the other hand, the number of Japanese publications put into foreign languages, notably English, is still very small.[6] In contrast to huge surpluses in merchandise trade, Japan has been maintaining equally huge deficits in "cultural" trade. But Japan's position as a net importer of culture and ideas is long standing: the practice easily goes back to the era when Buddhism, Chinese characters, and Confucianism were introduced to Japan.

Accordingly, the Japanese academic world has been traditionally inward-looking. The inward-looking character of Japanese science is also well known and has been criticized both at home and abroad from time to time. Overall, there are relatively few scientists of international reputation in Japan.[7] The social sciences in general[8] and economics in particular are no exception.[9]

Japanese scholars publish mostly for the popular domestic audience. Since the publish-or-perish pressure is virtually nonexistent once they attain permanent tenure status at the assistant professorship level, there is no strong and urgent need to continue to publish academic articles.[10] If they continue to write, they write for more lucrative media.

When fame is easily gotten in the domestic market place, academic or nonacademic, there remains no strong incentive to compete in the international academic market for recognition — which in any case is not necessarily given due respect at home. If a scientist wants to publish an academic article abroad, he must go through the rigorous refereeing process. When it is only his reputation abroad that he can embellish with such hard work, he prefers to accept the line of least resistance. He can publish his piece far more easily at home and thereby enhance his domestic reputation.[11]

Furthermore, in the social sciences, it is much easier to find a way to publish in international journals if the writings deal with abstract theory. Authors of such works are themselves very eager to do so.

Hence, in economics, a number of distinguished and internationally recognized mathematical economists and econometricians have emerged in Japan.[12] A social scientist engaged in research on Japan, however, tends to encounter far greater difficulty in having his research findings published in international journals. First of all, his piece must be of sufficient interest to foreign scholars. Not everything Japanese appeals to them. Secondly, unlike articles in the natural sciences or even mathematical economics, social science articles must be put into good English. Very few Japanese scholars possess such linguistic skills. If they assign their works to professional translators, they find translation fees to be prohibitively high, and the quality of the translation is not always acceptable.[13] Scholars would rather avoid this line of activity, and the field of economics provides no exception. Thus, most studies on the Japanese economy tend to remain unknown outside of Japan.

This situation implies that foreign scholars interested in studying Japanese economic affairs can essentially only depend on second-hand materials. This way, they cannot arrive at a full understanding of Japanese views on important economic issues. This lack of full understanding is quite serious, particularly when recurring international tensions — for example, between the United States and Japan — are fundamentally in the economic field.

The primary objective of starting the journal *Japanese Economic Studies* was, as far as I was concerned, to ameliorate this situation to some extent, however small, by translating significant studies conducted by Japanese economists on the Japanese economy and introducing these to non-Japanese economists. It is easy to say this, but I have found it very hard to practice it to my full satisfaction. I shall explain why.

Difficulty of literature searches

The first problem that the editor of a translation journal faces is where to look for materials. Let us see where Patrick and Rosovsky's "vast and detailed literature" is. A few impressive statistics suffice to convince the reader that they were not exaggerating.

The Union of National Economic Associations in Japan published a three-volume, 1,500-page survey of the state of economic studies in Japan commemorating its twenty-fifth anniversary in 1975.[14] It reported a total gross membership in 1974 of 17,000 in twenty-nine member associations ranging from accounting and business English to modern economic theory and Marxian economics. This

A Lakeside Village. Takehisa Yumeji, 1914.

number is impressive.[15] In the United States, the American Economic Association, to which most professional economists belong, had a membership of 14,700 in the same year. The survey volume provides other impressive statistics. Written by 170 scholars in 127 chapters covering 21 fields in economics and related fields, its author index lists some 3,500 authors and its bibliographies cite 7,500 references (articles and books) published mostly in the quarter century following World War II. It is troublesome to realize that this vast accumulation of the economic literature, representing a multiplicity of Japanese viewpoints, is virtually inaccessible to foreign scholars abroad. The core of Japanese economic studies — theoretical, empirical, historical, and institutional — remains unavailable to them.[16]

In Japan, publishing is a thriving business[17] despite frequent reports that Japanese are becoming less avid readers. The mass media are highly developed. Bookstores are the nerve center of downtown in any Japanese city. Economics has been one of the major fields of specialized publishing activity. Given the larger number of economists in Japan, this is not hard to understand.

Let me show how many periodicals on economics and related fields there are in Japan. A monthly journal, *Keizai hyōron (Economic Commentary*, published by Nippon Hyōron Sha), carries a bibliography section listing articles and books published on economics and management (including accounting).[18] From time to time, a list of journals covered in the bibliography is provided. Based on 1980 data, I have prepared Table 1, which tabulates the listed journals by source and frequency of publication per year. It shows an incredible total of 814 periodicals on economics and related subjects appearing in more than 3,400 issues per year. The table also reveals that there has been a significant upward trend in the number of periodicals (nearly doubling) and in the number of issues (an increase of 50 percent) from 1973 to 1980, even though the increase is partly attributable to a more complete coverage of journals by the bibliographers. However, not all of these journals specialize in economics. Therefore, a more accurate indicator is the size of the annual flow of economics articles and books. The above bibliography runs nearly twenty pages every month. The twelve issues of 1984 listed more than 6,400 articles and 738 books, consisting of 623 books by Japanese authors and 115 books translated from foreign languages into Japanese.

Even with the avid Japanese love of printed matter, who can read so many works on economics? What happens is that, as can be expected, most of them remain unread. Note that two-thirds of these journals are university journals, which are published by individual academic departments. Having its own journal confers academic prestige on a university department; hence, the very strong desire to publish one.[19] Such a journal is often published on a quarterly or semiannual basis (though nearly half of them are published only once a year).[20] Contributors are almost exclusively departmental faculty and graduate students. Such journals have a strong raison d'être because departmental members need space for the number of articles required for appointment and promotion. As house organs, they require no refereeing. Quite commonly, any faculty member can publish whatever he wants when his turn comes. Many of the articles are just lecture notes in disguise or commentaries on the works of foreign scholars. Knowing this, nobody is willing to read such journals, which merely fill up library shelves. Gresham's Law operates. Even though outstanding studies appear in these journals from time to time, they are lumped together with the unworthies and tend to be neglected by the profession. University journals appear for the sake of publishing, not reading. This is a poor way to accumulate knowledge. The matter is made worse in academic economics because of the predominant influence of Marxian economists. Two-thirds to three-quarters of university economists, having a Marxian background in economics training, tend to write in Marxian jargon, adding to the nonreadability of their works. Of course, many of these articles are purely theoretical and have nothing to do with Japanese studies. However, even when they explicitly deal with the Japanese economy, they often tend to be too esoteric to be of interest to any but a very few specialists.

In short, the only university journals with high stature are those published by a few leading universities. The only significant university journal in economics with an interuniversity character is *Keizai kenkyū (Economic Review)*, published by Hitotsubashi University's Institute of Economic Research, which places heavy emphasis on empirical studies of the Japanese economy. Needless to say, journals published by academic associations (see Table 1) are also interuniversity in character and are qualitatively superior to university journals. The most outstanding among them is the *Kikan riron keizaigaku (Economic Studies Quarterly)* of the Japan Association of Economics and Econometrics, which has successfully enforced the refereeing system for more than two decades.

Table 1. Economic Periodicals in Japan

A. 1980 Breakdown

Publication Sources

Frequency of Publication per Year	Universities and their research institutes	Government agencies, their research institutes, and semigovernmental research institutions	Private corporations and labor unions and their research institutes; private research institutions	Academic societies	Commercial publishers	Total by Frequency of Publication	Total by Number of Issues per Year
52					5	5	260
36					2	2	72
24		1	1		1	3	72
12	13	39	38	4	35	129	1548
6	31	2	6	2	1	42	252
4	92	24	9	8	12	145	580
3	34	2	3	1	1	41	123
2	85	2	1	6	2	96	192
1	226	15	10	8		259	259
Irregular	65	14	8	5		92	92[a]
Total by Publication Sources	546	99	76	34	59	814	3450

B. Changes from 1973 to 1980

1973	281	50	38	16	46	431	2229
1977	476	86	70	16	70	720	3315
1980	546	99	76	34	59	814	3450

Source: Tabulated from the Institute of Economic Research, Osaka City University, "Bunken geppō shūroku-shi ichiranhyō" (List of Journals Covered in the Monthly Bibliography), *Keizai hyōron*, 22 (June 1973): 135–49; 26 (October 1977): 135–57; 29 (December 1980): 174–201.
[a] Assuming one issue per year.

There are a number of periodicals published by government agencies, banks, labor unions, and other organizations (see Table 1). They provide economic statistics and research staff articles on contemporary economic problems. They are competently executed and sometimes quite academic, as is true of *Keizai bunseki (Economic Analysis)* which presents research articles by the staff of the Institute of Economic Research of the Economic Planning Agency.

Finally, as is shown in Table 1, there are quite a number of commercially published journals, predominantly published on a monthly basis. They completely or partially specialize in economics and business. They range from business weeklies — like the *Tōyō keizai (Oriental Economist)* and the *Mainichi ekonomisuto (Mainichi Economist)* — to intellectual monthlies — like *Chūō kōron (Central Review)* and *Sekai (World)* — which cover economics as part of their main fare. Specializing wholly in economics are, among others, *Keizai hyōron (Economic Commentary,* monthly) for the mature public, *Keizai semina (Economic Seminar,* monthly) mostly for undergraduate economics majors and junior businessmen, *Kikan gendai keizai (Quarterly Contemporary Economy)* for a highly sophisticated audience, and *Kikan chūō kōron (Quarterly Central Review on Business Problems)* for the intellectual business community. All of these carry quite high-quality studies of the Japanese economy. There are reasons for the proliferation of commercial journals on economics. Any economist who wants to express and disseminate his ideas to a wider audience beyond academia tries to publish in popular journals that command a sizable intellectual readership. Contributors who are accepted by the editorial staff of those journals can elevate themselves to the exalted status of opinion leaders. They can kill three birds with one stone: they can satisfy their desire for self-expression; they can gain some measure of fame; and they can make money to boot. As a matter of fact, many of these popular articles are quite excellent. Since they are written more or less for the general public, they use less gibberish and make points more forcibly than esoteric and pedantic academic articles.[21]

This critical analysis of Japanese economic periodicals suggests that the vast economic literature in Japan is probably not so vast as it may seem at first sight. Even so, the amount is so huge, and the relevant literature is so scattered that it becomes quite a job to try to search for suitable materials for translation.

There is another complicating feature in the literature search. In the United States, important academic contributions are usually made initially as articles in academic journals, some of which are eventually developed into monographs and books. Not so in Japan. Since academic journals of high stature are few (and scholars do not read them), scholars tend to devote themselves to publishing the results of their research in books. These academic books provide a promising hunting ground for our journal. A chapter or two may be excerpted from a book to give its essence. In fact, a number of my selections came from such sources. A related phenomenon is the popularity of lecture *(kōza)* series, conference proceedings, and collected essays. A number of them deal with the Japanese economy and are in fact also useful sources of material. However, the problem that one faces is their abundance. As I have noted, 623 books were published on economics in 1984 alone. Of course, not all are concerned with Japanese economic studies, but, as might be expected, a sizable fraction of the books focus on Japan. The logistics problem with books is that they are not so readily available to me as are periodicals, which are regularly available through subscription. Japanese books have become as expensive as American books and are actually more expensive when ordered through book importers in New York. Thus, for economic reasons, I must wait until a book establishes its reputation in Japan.[22] Even then, there is no guarantee that a book with wide popularity in Japan will appeal to foreign readers.

Having surveyed the availability of materials for our translation journal, let me now show how my selections have actually turned out. Table 2 summarizes them by source.

Table 2

Sources of Articles in *Japanese Economic Studies* (Volumes I-X)

Sources	Number of Sources Used	Number of Articles Translated
Books	27	28
Conference Proceedings and Collections	10	17
Academic Journals	6	20
Nonacademic Journals	14	32
Previously Unpublished		8

The table speaks for itself. Since the selections have been made over the years without preconceived design, I am confident that this breakdown indicates the relative importance of the different sources. Academic journals, which one might naively believe to be the best source, produce a very poor showing, except for *Keizai kenkyū* and *Nihan rōdō kyōkai zasshi*. This has made my literature search all the more difficult.

In this connection, let me add one more set of statistics. Table 3 refers to a breakdown of authors by academic affiliation.

Table 3

Affiliations of Contributors to *Japanese Economic Studies*
(Volumes I-X)

Types of Affiliations	Number of Institutions	Number of Authors	Number of Authors by Affiliations
National Universities	10	37	Hitotsubashi University 10 Tokyo University 8 Kyoto University 5 Nagoya University 4 Yokohama Kokuritsu University 3
Private and Municipal Universities	14	28	Keiō University 7 Seikei University 3 Chūō University 3 Senshū University 3
Government and Semigovernmental Agencies	6	17	Economic Planning Agency 6 Bank of Japan 4
Business and Nonprofit Organizations	15	17	Japan Economic Research Center 3
Foreign		10	
Total	45	109	

Considering the prestige national university scholars enjoy in intellectual circles in Japan, I am sure that my selections are fairly impartial, providing a relatively unbiased representation of opinion leaders in the economics field.

Selection criteria

The editor's primary function is to search for suitable materials in original sources, either directly by going over journals and books himself or indirectly by soliciting suggestions from his advisors and friends. In this activity, he must establish some selection criteria. Let me now turn to this aspect.

I have indicated some of the difficulties I have encountered in making selections for our journal. You may wonder why. To begin with, our journal is small, with each issue carrying about 35,000 words[23] in three relatively lengthy articles, each equivalent to about 40 pages of manuscript (double-spaced). Thus, the journal can publish only a dozen articles a year. The editor must be exaggerating when he insists that it is difficult to select a dozen articles from the "vast and detailed literature on the Japanese economy." It is not so.

First of all, the vast literature (though not so vast after screening it as mentioned above) is written solely for the Japanese readership. What interests Japanese readers may not necessarily excite non-Japanese readers. The two groups have different interests. The editor has a hard job finding articles which have a sufficiently international appeal when they have been written with the Japanese audience primarily in mind.[24] This criterion cuts down the vast

literature to manageable size.

Another requirement is the permanence of an article. Many journal articles are only of momentary interest, dealing mainly with current topics. It takes a minimum of one year from the selection of an article to its publication.[25] So an editor must try to find articles which have at least medium-term permanence.

What appeal is the editor looking for in an article? This is hard to define. Above all, the article must be informative. Next, it should have a strong point of view. It may be called a Japanese view, and the more Japanese it is, the better. One measure I use is my own self-interest. An article that I select must be, first of all, appealing to me and one that I would want to quote as a reference, should I write something on its subject. In any case, I confess that my selections heavily reflect my personal preferences. Though I solicit others' advice, more often than not I am unable to accept the articles they suggest because they do not meet my criteria.

An economy is multifaceted. To cover the multifarious facets of the Japanese economy, I have to go far beyond my narrow area of specialization. Economics is a vast field consisting of widely different subfields. Nowadays no single scholar can know everything about any discipline. It is very common for economists, like other social scientists, to specialize very narrowly and to know next to nothing outside their area of expertise. A journal like ours, however, cannot specialize and must publish on a wide array of topics. To cite just a few subjects that the journal has carried, we may mention labor relations, industrial organization, aging population, business management, economic policy, economic history, pollution, international trade and finance, and poverty.[26] This means that the editor must be a Renaissance Man. Even if he does not know too much, above all an editor must have good sense and taste and the ability to discriminate between good and bad.

Before I embarked on editing the journal, I had this idea of how I would allocate space to the articles: there would be one paper on a survey of the literature, reviewing important contributions of Japanese economists to whatever subject was under study; one academic article featuring high-powered economic analysis; and one relatively light article, along political economy lines, discussing policy issues. I still believe that this allocation is well balanced. But this is an ideal that is more often than not violated in practice.

The journal has an advisory committee consisting of four American and five Japanese economists,

all well known in Japanese economic studies. The members are supposed to give me learned advice on editorial matters and suggest possible selections. Unfortunately, all of them are busy men, usually overcommitted, and I cannot demand too much of their time on the journal's behalf. Therefore, I conceive of them more as acting in the capacity of watchdogs over the quality of the journal. The editor needs moral support since a journal of this type, particularly one with a small circulation, seldom receives direct reader responses. The editor, therefore, cannot see signals which tell him whether he is doing a good job or not. The advisory committee can at least tell the editor how he is doing.

Translation problems

While the editor's primary function is to select articles for translation, the great bulk of his time is spent on overseeing translations. As everybody connected with the translation business knows, there is a perennial dilemma. Above all, translations must be readable. Ideally, they should be esthetically pleasing (even in academic writings!), or at least they must not offend the readers' sensibilities.[27] Such translations can only be accomplished by native translators. Translators of fiction strongly insist on this point and I fully concur with them. Unfortunately, the supply of native translators for the economic literature is almost nonexistent and if they exist, we cannot afford them.

Besides, there is another side to translations of technical materials in disciplines like the social sciences. The translations must be accurate, for which translators must have a good knowledge of things Japanese. In my experience, such knowledge can be expected much more readily from Japanese translators. Should we put beauty before accuracy or the other way round? This is a matter of taste. However, readable translations by American translators very often contain inaccurate or inappropriate translations of technical matters. Such inaccuracies stand out like a sore thumb, or a misprint, to knowledgeable readers.

Translators of economic articles must have training in economics. Like other scientific disciplines, economics uses a great deal of technical jargon. Translators must be able to establish exact correspondences between English and Japanese technical terms. This may seem an easy job to the uninitiated. (After all, economics was imported from abroad into Japan and many technical terms were initially transliterated verbatim into Japanese.) While this is true to a certain extent, translators can master the one-

to-one correspondence only if they are equally conversant in both the Japanese and the English literatures.[28] In other words, they must have received training in economics both in Japan and in the United States. Preferably, such translators must have reached a level of proficiency equivalent to passing the Ph.D. qualifying examination in economics. On top of that, they have to be good English writers. It is impossible to find someone who satisfies all of these requirements. If there were such a person, he or she would be unlikely to waste his or her time translating other people's work.

There is a fundamental difference between translating fiction and technical materials. The former is usually undertaken by academicians in the humanities who can cite their translations as academic achievements and who are not too concerned with pecuniary returns for their work. The latter is done mostly by professional translators who work for pay. While social science works are academic studies, their translators cannot claim them on their curriculum vitae unless they are of a sufficiently academic character (like historical accounts or politicians' diaries).[29] They are thus semiacademics if not professional translators. If making money is the objective, academic translation work is a losing proposition. Suppose that one is paid thirty dollars per thousand words.[30] Let us assume an experienced translator can produce about two hundred words an hour — including typing time. (I imagine that translations from European languages can be executed more quickly.) This comes to an hourly rate of six dollars. Even as part-time employment, it does not pay enough to induce well-qualified persons to spend time translating. The pecuniary incentive is simply not strong enough. I wish we could pay enough to entice highly qualified translators — assuming that they exist (of which I am quite doubtful). Unfortunately, the simple matter of economic survival keeps a specialized journal like ours with a small circulation from enjoying that luxury.

Under these circumstances, we are lucky if we can get the second best or even the third best for translators.[31] The net outcome is that the editor has to contribute a great deal of his time to improving draft translations to what he hopes is a satisfactory level. Almost always, extensive rewriting is required. This is a real chore, but since the journal bears the editor's name, the quality and accuracy of translations are his responsibility even though the translators are given credit.

After a number of years at this job, I am very experienced in overseeing translations. I handle this time-consuming job in the following manner. I go through three rounds. In the first round, I make a very careful verbatim comparison of a translation with the original. I rewrite extensively as a general rule. Some questionable passages are set aside at this stage for checking later. It is often necessary to make a trip to the library.[32] In the second round, I put aside the original and read the corrected translation, listening to how it sounds in English. I try to make it idiomatic. Additional corrections become necessary at this stage. By the end of this round, the translation is in virtually completed form. However, to make doubly sure, I go through a third round to try to uncover remaining oversights.

The time I have to spend on this exercise varies from one paper to another and from one translator to another. Some authors are easy to translate. Others are so fuzzy that it becomes almost a trauma to attempt translation. My rough guess about the time I spend is that on average I cover 800 to 1,200 words an hour (combining all of the three rounds). Since one issue contains about 35,000 words, I must be spending some 40 hours an issue and 160 hours a year just to correct translations. This is a great deal of time for a small journal like ours.[33]

The heavy time burden is a drain on any scholar who wants to be active in his own research. If one examines the situation in terms of alternative projects any editor must abandon, it is a stupendously costly job. This is particularly so with me because I am not a Japan specialist by profession. (I teach economic theory.) I get very little credit from my employer for my professional achievements in this line of activity. I am completely on my own. So I count my cost as zero. Otherwise, I cannot justify my use of time, especially as inflation more than halved the real remuneration. After all, as an economist, I preach to my students the virtue of rational allocation of scarce resources like time.

While overseeing translations is quite time consuming, it still is less time-consuming than undertaking translations myself. Even though I can work fast and am by now a well-seasoned old hand at translation, I must spend at least twice as much time on original translations. Since I want to maintain a high standard, I have to make an extremely large number of corrections and do extensive rewriting with draft translations to satisfy myself. My subjective judgment is that my corrections amount to 30 percent, even with the best of our translators, and frequently to 50 percent.

Let me move on to explain what I correct in draft translations. I have already noted that technical terms have to be given exact English counterparts. This is not a simple job. To accomplish it properly,

one has to be very familiar with both the English and Japanese economic literature over a wide range of economic subjects. Having had economic training on both sides of the Pacific, I have a good command of economics as pursued in the United States and in Japan. This experience is extremely useful in performing this part of my editorship. Nonetheless, my own specialization and interest are limited, even though I have tried to keep abreast of many more economic subjects than is common. Therefore, from time to time I have to walk on unfamiliar ground and, in such instances, I am not too sure of my own work. Though I strive for perfection, there is a limit to what a single individual can do. Every researcher knows that on occasion he has to spend a great deal of time just to find a single number. It is much easier not to look for it if nobody else notices it. So he is very tempted to take the easy way out by omitting the number or just making a guess. Translators often find themselves in the same situation. It is much easier to guess than to spend a great deal of time attempting to find the exact English counterpart for an obscure Japanese word. As I myself have been guilty of this practice from time to time, I should be the last to cast stones at others, but one should not give up trying to attain perfection.

In addition to technical terms, there are always peculiarly Japanese expressions that cannot be easily and readily rendered into English except in a very clumsy way. I think that these are the ones that tend to mar any translation. One can only deal with this problem by attempting free translations unshackled by the original. This may be more desirable in translations of novels, and less fitting for translations of academic writings, particularly when seeking accuracy before beauty. So while I am sensitive to the need to avoid clumsy expressions, I have to let them stand on occasion. I must admit that I have to rely on my 93 percent English.[34]

I am not saying, however, that I give up beauty in favor of accuracy. While I put accuracy before beauty, I also strive for readability to the fullest extent possible. Needless to say, I am not a native speaker of English and there are limitations to the English produced by the foreign-born, however bilingual they may become. I always compare the best English written by foreigners to distilled water. One can drink it with no harm, but one cannot expect good flavor or taste from it. After all, what is called the style of a writer is essentially like the impurities in natural water.

One common problem in translating from the Japanese is that translators tend to be heavily influenced by the original Japanese sentence structure. A great deal of practice and a good ear are required to free oneself from this common pitfall.

To make things worse, some authors write very poorly, in a tortuous style, characterized by long-winded sentences. Sometimes, they are even illogical. What should a translator do? Should he "transliterate," keeping the translation as garbled and confused as the original? Translators are apparently incapabale of adopting this strategem. They must present readable and intelligible pieces. A tour de force is required to convey the original's meaning coherently and accurately in English, a fact not too well appreciated by the foreign reader.

Japanese is a far less logical language than English. The other side of illogicality seems to be repetitiveness, and accordingly Japanese writings tend to be repetitive and redundant. From time to time, I use the editor's prerogative to edit the text. Ideally, I should ask the author of such a text to rewrite it but lack of time usually makes this action unfeasible. (Also these authors are usually too busy and are therefore unwilling to rewrite what they regard as finished.) A good refereeing process in Japan would mimimize this sort of problem.

My belief that translations should be accurate makes me side with those translators who take liberties with the original to make it more intelligible. What is involved in maintaining accuracy is not perfectly faithful rendering but accurate conveying of the original overall meaning.

This brings us to the question of how far a translator is allowed to "improve" upon the original when logic is apparently lacking? May he reorganize sentences to make the flow of thought smoother and less unintelligible? Should he remain faithful to the original at the sacrifice of readability? To do full justice to this important aspect of the translation process requires far more time than I have at my disposal. Fortunately, the problem is not too serious for economic articles which concentrate on the factual aspects of the Japanese economy.

Let me conclude this rather rambling discourse on my experience as the editor of *Japanese Economic Studies* by stating that I am pleased to learn that our journal is the only translation journal on Japan successfully published in the United States.[35] To me, it seems a minor miracle that the journal continues to be published. The logistical difficulties alone are formidable. It is difficult to locate and secure a continual flow of high-quality articles and retain qualified translators. Above all, it is difficult to maintain my own enthusiasm for the project. It is gratifying therefore, to be told from time to time about the high quality of the journal I try to maintain.

Financial Concerns

Finally, there are the inevitable financial problems that a journal of this type must face. The finances are the publisher's responsibility, but may I note that my journal has been run as a strictly commercial venture with no subsidies from any source. Publishing a journal like this is essentially an attempt to create demand where there has been none. While there is a "vast and detailed literature" on the Japanese economy, it cannot be introduced abroad unless there is a demand for it. Needless to say, the test of the market is always harsh and cruel. Journals designed primarily for the academic market are put to the test particularly when so many journals are competing with each other for the limited resources of libraries and private scholars. Journals like ours with limited marketability can only hope to survive by cutting costs — more bluntly stated, by exploiting the editorial staff. For instance, it would be absurd for me to continue the editorship if I valued my time at the commensurate commercial rate.

Here lies the inherent difficulty in this kind of an enterprise. We all deplore the imbalance in the cultural exchange between the United States and Japan. We are all aware that something practical should be undertaken to reduce the imbalance. Having engaged in this job, I now know that it is much easier to keep on deploring. If I knew beforehand how much time I would have to devote to the job and how little I could get back in the form of pecuniary return, I would have had second thoughts. Government efforts are now being stepped up but government assistance often tends to be wasted unless people are dedicated to the mission. Without their dedication no amount of assistance and aid can bear fruit. Having committed myself to the objective of setting up a journal to give wider exposure to Japanese economic studies produced by Japanese economists in Japan, I am proud that I have been instrumental in helping to realize this objective. But mine is only a small contribution. I hope that many more will dedicate themselves to this sort of thankless *(ennoshita no chikaramochi)* job.

Notes

1. See Ezra F. Vogel, *Japan as Number One, Lessons for America* (Cambridge, Mass.: Harvard University Press, 1979).

2. The supply of such experts has not been growing. The 1978 *Annual Report* of the Japan-United States Friendship Commission notes: "Despite a national need for understanding and analysis of the economy of Japan, and job opportunities in business, government and the universities for economists trained on Japan, the Commission received evidence that scarcely more than one American Ph.D. graduate in economics was being produced nationally per year with special competence on Japan." In an attempt to ameliorate the situation, the Commission gave a continuing grant to the committee on Japanese Economic Studies to finance half-stipends for doctoral students pursuing Japanese economic studies. The program has achieved some success, but there remains a problem with the caliber of graduate students in the field.

3. There has been a sign of improvement in the last few years as a few economics journals in English are being published in Japan — e.g, Ministry of International Trade and Industry, *The Journal of Japanese Trade and Industry*, Keizai (1982) (bimonthly); Bank of Japan, *Monetary and Economic Studies* (1983) (quarterly); Kōhō Center (The Japan Institute for Social and Economic Affairs), *Economic Eye* (1980) (quarterly).

4. Hugh Patrick and Henry Rosovsky, eds., *Asia's New Giant: How the Japanese Economy Works* (Washington, D.C.: Brookings Institution, 1976).

5. Ibid., pp. vii–viii.

6. There is also a sign of improvement in this area. Foreign publishers have become more willing to publish Japanese translations. In the economics field, the Macmillan series on "Studies in the Modern Japanese Economy" began its operation in 1984. In Japan, Kodansha International has become active. Nonetheless, the high cost of translation remains a serious bottleneck.

7. In an interesting study, Shimbori Michiya computed the ratio of the number of living internationally recognized scientists appearing in *World Who's Who in Science* (1968) to the total number of scientific researchers in leading nations as reported in the *Kagaku gijutsu yōran*

(*Handbook of Science and Technology*) compiled by the Science and Technology Agency of Japan and published in 1970. (Scientists were limited to those in the natural sciences, the health sciences, and engineering.) His figures are as follows (per 1,000 researchers): Sweden (23.5); U.S. (16.5); Italy (14.8); U.K. (13.1); Canada (11.7); West Germany (11.4); Netherlands (9.0); France (8.8); Japan (2.4); and U.S.S.R. (0.8). See Shimbori, Michiya, *Nihon no gakkai (Japan's Academe)*, Nikkei shinsho (Tokyo: Nihon Keizai Shimbun Sha, 1978), p. 162. However, some change may be occurring in a few specific fields such as the high-tech field. Kikuchi Makoto (Director of SONY's Research Laboratory) reports that the number of articles reported by Japanese participants to the International Electronics Device Meeting increased sharply (the share rising from 8 percent in 1976 to 31 percent in 1983). See Kikuchi Makoto, "Nihongata sōzōryoku no himitsu" ("Secrets of Japanese-style Creativity"), *Bungei shunjū* (March 1984): 112–127.

8. See Organization for Economic Cooperation and Development, *Social Science Policy: Japan* (Paris: 1977).

9. Mark Blaug and Paul Sturges, *Who's Who in Economics* (Cambridge, Mass.: MIT Press, 1983) lists 640 major living economists based on Social Science Citation Indexes. Of thirteen Japanese included in the volume, seven reside outside Japan (including this author).

10. See Shimbori, *Nihon no gakkai*, pp. 116 ff, for the academic productivity of Japanese university professors.

11. There arises a sort of division of labor between those who write for the domestic popular press and those who write for the international academic community. At home, the latter tend to be less well known than the former.

12. Of the thirteen listed in *Who's Who in Economics*, six can be regarded as specialists in this field. Two of them served as presidents of the Econometric Society, an international academic society in this area. For Japanese economists' international contributions, see my "Kagakusha seisansei no bumpu" ("The Distribution of Scientific Productivity"), *Kikan riron keizaigaku*, (August 1971): 51–72.

13. According to my small-sample observations in Japan, the translation fee is about twice as high in Japan as in the West and with no guarantee on the quality of the finished product.

14. Nihon Keizai Gakkai Rengo (The Union of National Economic Associations in Japan), *Keizagaku no dōkō (The Trend in Japanese Economics)* (Tokyo: Toyo Keizai Shimposha, 1974–75). A follow-up volume covering the years 1971–80 was published in 1982, listing 2,500 volumes.

15. In 1983, membership was 22,500 in thirty-two member associations (the union's *Information Bulletin*, no. 3 [1983]). There is no single nationwide economic society like the American Economic Association in Japan.

16. See Kazuo Sato, "The State of Economic Studies in Japan," *Japanese Economic Studies*, 4 (Spring 1976): 90–100.

17. From 1973 to 1983, the number of published book titles rose from 27,354 to 31,297 and the number of periodicals from 2,700 to 3,565 (Shuppan News Sha, *Shuppan nenkan [Yearbook on Publications]*). As Japanese typesetting is a highly labor-intensive operation, the rise in labor costs threatened Japanese publishers in the 1970s (forcing some of them to subcontract typesetting to printers in Korea and Taiwan). A recent technological breakthrough allows publishers to dispense with the services of expensive typesetters.

18. There are other economics bibliographies. See The Division of Economics, Commerce, and Business Administration, Science Council of Japan, *Quarterly Bibliography of Economics* (Tokyo: Yūhikaku). See also the Union of National Economic Associations in Japan, *Bibliography of Japanese Publications of Economics, 1946–1975* (Tokyo: University of Tokyo Press, 1977), which is a summary bibliography prepared in English for distribution at the Fifth World Congress of the International Economic Association in Tokyo in the summer of 1977.

19. The numbers of colleges and junior colleges increased considerably through the 1970s. [Colleges: 382 (1970) to 458 (1983); junior colleges: 479 (1970) to 532 (1983).] This accounts for the steady increase in the number of university journals.

20. Small colleges usually publish a journal for the entire faculty. So long as they carry economics articles, they are listed in the bibliography. Also, noneconomics journals in humanities, history, law, agriculture, and so on are listed for the same reason. However, English-language journals (like *Kyoto University Economic Review* and *Keio Economic Studies*) are omitted from the list.

21. However, the number of commercial journals has been on the decrease in recent years because of falling readership of intellectually rigorous material. *Kikan chūō kōron* was discontinued in 1982, and *Kikan gendai keizai* suspended publication in 1985.

22. The falling interest of Japanese readers in intellectually difficult material has affected sales of academic books. Hence, major publishers have become reluctant to publish them unless subsidies are obtained. Even so, the unit price of such a book has risen considerably. When the price exceeds, say, $20.00, sales fall off rapidly. Consequently, publishers shift from difficult books to easy ones to augment their sales.

23. This comes out to about ninety printed pages. My rule of thumb is that one printed page of the journal corresponds to one printed page in Japanese books, one page usually containing 750 *ji* (characters). So one issue contains about 70,000 *ji*.

24. Such articles may take many things for granted which may be incomprehensible to the foreign reader. But my experience indicates that this problem is not very serious in the economic literature.

25. The time includes editorial correspondence with the authors and the publishers to obtain permission for translation rights, getting the articles translated, editing, correcting, typesetting, and printing. A number of bottlenecks slow down the process: frequently authors do not reply promptly; several letters may have to cross the ocean; the translators may reject the commissioned pieces; the editor may be tied up with other pressing business; and so on.

26. Since the journal is small, I frequently devote an entire issue to a special topic. So far, 60 percent of the issues have been this type.

27. Many Japanese publications in English do not even satisfy this minimum requirement. Book reviewers rightfully make fun of such works.

28. To cite a few examples at random, *shigen haibun* is invariably translated by non-economics translators as "distribution of resources" rather than "allocation of resources." *Shūchūdo* is a translation of "concentration ratio" but it is often translated back into "degree of concentration." While every Japanese economics major knows that *genkai shōhi seiko* is "marginal propensity to consume," non-specialists probably have no inkling of the correspondence between the two. To make things

worse, there are many English words coined in Japan, e.g., "salary-man." When they are abbreviated, translators may have a hard time. A translator could not understand what "be-a" is, which is short for "base-up," a "Japlish" word for across-the-board wage increase.

29. In Japan, scholars can cite translations into Japanese as significant academic contributions, and the public regards them as such. Translators have much higher social standing than in the United States. Moreover, they are better paid.

30. This was quoted to me as the average going rate paid by the U.S. government in 1979. My publisher told me that the current (1984) rate was thirty to forty dollars per thousand words — about double that paid for Chinese and European translations. (Over the last ten years, the rate seems to have remained virtually unchanged.)

31. Over a dozen years our journal employed both American and Japanese translators. The Americans have all vanished, and we are left with only the Japanese. The maximization-of-profit principle seems to be working here.

32. A good reference library is indispensable. I owe a great deal to the Columbia University Library, especially its East Asian Library.

33. However, since four issues a year come to about 140,000 words, the work is equivalent to doing one book a year. No doubt it takes as much time.

34. I borrow this expression from my former colleague, Prof. Michio Morishima (now with the London School of Economics), *Theory of Economic Growth* (Oxford: Clarendon Press, 1969), p. ii. I call my English *Eigo-modoki* (in the style of English) to distinguish it from the genuine article.

35. See K. K. Kobayashi and W. Tsuneishi, "Draft Report on Translation Aids and Centers," Library of Congress, May 10, 1979.

THE ODYSSEY OF A TORTOISE
Translation in the Social Sciences as a Losing Proposition

by Tsutomu Kano

Tsutomu Kano is an internationally known translator who worked for some years as the editor of *The Japan Interpreter*, a leading journal of translations in the field of the social sciences published from 1963 to 1980. In addition, he has produced a number of distinguished book-length translations, among them (with Patricia Murray) an English-language version of Kuwabara Takeo's *Japan and Western Civilization: Essays on Comparative Culture*, published by the University of Tokyo Press in 1983.

In his essay, Mr. Kano discusses some of the practical issues facing the editor of a journal that publishes a large volume of translated material. Although *The Japan Interpreter* is no longer published in the form described in the essay, the points Mr. Kano made at the time of its composition in 1979 are still as trenchant, and as timely, as when they were first articulated.

A Village at the Foot of a Mountain. Takehisa Yumeji, 1909.

 It has been about ten years since my last visit to Washington, or the United States, for that matter. The last time I came here, hoping to find some possible sources of assistance for *The Japan Interpreter*, I left our staff in Tokyo mapping out the details of a small commercial venture. They were going to produce handkerchiefs, I think, with the words "Beware the Ides of March," or some such pithy advice printed in English on them. They were clearly not optimistic that my visit would produce anything, and were preparing for the worst. Thank heavens we never had to rely on handkerchief sales to keep the *Interpreter* going, but the person who did more than anyone else to ensure continued publication was Dr. James Morley, our panel chairman. Without his help, our journal would have ceased publication ten years ago.

This visit the catastrophe at home is one of perception rather than substance, but in a sense it is almost as serious. That is the report, once again, that our journal is about to fade out, but this time the report is entirely unfounded. Let me assure you that it is very much alive. The staff in Tokyo is busily occupied not with designing handkerchiefs, but proofreading galleys for the next issue. And —perhaps Dr. Morley will breathe easier— I do not have to ask him to help this time! We no longer have the support of the Japan Society and the Japan Center for International Exchange, but we can and will continue publication on our own. George Akita of the University of Hawaii once paid me an extraordinary compliment — he said that if he were stranded on a desert island and simply needed the determination to not give up, the person he would like most for company would be me. At least I *think* it was a compliment!

In any case, we are still in business, in our less than punctual fashion, and I give much of the credit to Dr. Morley. When he was Special Advisor to the Ambassador in Tokyo, he was concurrently chairman of the Fulbright Commission. Among other initiatives he took to help establish a firm base for the journal, it was his idea and his active support that made it possible for an American postdoctoral Fellow in Japanese Studies to be sent to the *Interpreter* each year under the Fulbright program.

Our tenth grantee is now about to complete his year with the journal. The idea behind the arrangement is mutual help: while the Fulbright scholar serves as editorial advisor and senior translator for the *Interpreter*, he can also learn from the staff some of the secrets of professional translating in the social sciences. He also has a good opportunity to become more familiar with current Japanese thinking, and social and political affairs. A one-year internship at the *Interpreter* gives young scholars a chance to refine their language skills and master at least certain areas of translation before they go on with their postdoctoral research.

It is good to be able to report that our relationships with all ten grantees have so far been very productive and successful. Some naturally benefit from their year more than others, but by and large after ten months they are able to produce the kind of translations that we consider up to standard. That means, very briefly, producing an integrated piece of writing which can stand on its own linguistic merits as a polished English essay, and at the same time faithfully reflect the ideas, intent and, if possible, the style of the author.

I will elaborate on that statement later, but let me first describe how we approach our work in Tokyo. Our translators, including the Fulbright scholar, do not work alone. We work in teams, bringing the skills and knowledge of at least two people and sometimes more, to each translation. Sometimes a native speaker of English and a Japanese together produce the first draft, or the native speaker may prefer to do the first draft alone, with occasional help from his Japanese colleagues. In either case, he must produce a second draft, which is then heavily edited by another native English speaker and then carefully checked for accuracy and style by a Japanese editor. At least five people, including the typist, participate to produce a final draft which is then presented to the author or client for approval.

For us, any translation is a joint product, the fruit of binational cooperation between Japanese and, so far, Americans. We work on the assumption that the Japanese contributes his knowledge of the Japanese language and his understanding of the original text while the American takes responsibility for writing the English version and contributes whatever understanding he has of the subject matter. Theoretically this method is foolproof. It should go like clockwork to turn out page after page of translation that would make any Japanese author proud to be represented in English. But the clock does not always work. After eighteen years in this business, I have finally accepted the dull truth that well-educated Japanese do not necessarily always understand what they read in their own language, nor are well-educated Britishers or Americans always able to write intelligible English prose.

As all of you know all too well, just to get the

literal meaning of the words down on paper is often worse than retrogressive; such treatment can place the reputation of the actual author in danger. To do him justice, the translator must be able to understand exactly what the author is trying to say, semantically locate each sentence in the context of the essay as a whole, and even read between the lines. Moreover, he must know something about the intellectual background of the author and be able to see him and his work within the broad intellectual milieu of contemporary Japan. With that kind of understanding, a translator or a team is prepared to follow the stream of consciousness, if not the logic, of the work in hand. This is definitely a commentary on the academic style of many Japanese scholars. Call it pedantry if you will, irrationality, or even carelessness — from the point of view of strict rules for English writing those labels may apply. But the fact is that the Japanese reading public and the academic world absorb material in ways that the translator simply has to understand. He must be able to glean the meaning in a vague reference, and to fill in where words are left out. He should be able to paraphrase where necessary and explain sentences with examples. In short, the translator becomes an interpreter, and an illustrator, as well as a carpenter filling out a structure that may only be suggested. Without that effort, which may already go beyond the bounds of what you consider to be a translation, I think that some Japanese writing may indeed be untranslatable.

When I speak of being able to write decent English, I mean the ability to express the ideas of the author on a level that is comparable to the writing of his American counterparts. No matter how poorly or loosely written the original text may be, or no matter how vague or illogical it may seem, as long as it is selected for translation, the translator must be able to turn it into a well-organized, readable essay.

These are pretty heavy demands to place on someone, Japanese or American, who is probably underpaid, inadequately acknowledged, and may have ulterior motives for translating in the first place. Years ago I expected all so-called translators to be at least aiming for such heights, but nowadays I find myself dumbfounded to come across someone with these capacities who actually wants to be a translator. Such people are rare. Most persons involved in translating, even if they are almost bilingual, have gaps in their skills or knowledge. Even some of our Fulbright scholars, while being fluent in spoken Japanese, could not see for some time why a word-for-word translation was unacceptable. This occurs when the translator does not fully understand the text; but the more important problem is attitude. The factor that brings a translation to life is a sense of commitment to producing a first-rate piece of work. It is a dedication to an essay that will never be his own, and that takes unflagging pride and high standards, combined with humility.

Brains alone are not enough. Shall I list the virtues? Patience, and a willingness to spend time, labor over trifling problems, research and fill in all necessary supporting material, consult others constantly, and accept suggestions. Paradoxically, imagination and creative *gomakashi* (deception) can be virtues, while sloppiness or hedging are terrible liabilities.

In Japanese-to-English translation in the social sciences, a native speaker of English can be trained in the necessary skills, and if he has even some of those personality traits that will carry him along, he can become a superior translator. It is extremely difficult to train Japanese in English translation, on the other hand, for the simple reason that today very few Japanese can write sophisticated, natural English by themselves.

Some years ago I experienced this pitfall when an American colleague and I were asked to teach translation to a selected group of Japanese on the staff of a large English publication. May of them spoke beautiful English, but when it came to writing, they were held back by the inability to switch thought patterns. Early on in our four-year course they discovered that they really did not understand all of the Japanese texts we were using, and the result was a strange English paraphrase of the content in the way they understood it — obscurities, nonsequiturs, malapropisms, and all. I honestly think reaching that point was the most constructive thing we did, because the subsequent problem — what to do about it — could not be solved until they learned how to write. How to use connecting words, how to shift or place emphasis, how to balance a sentence and lead to the next — all this is normally absorbed during the sixteen years of education that a native speaker has behind him.

Japanese have a crucial role to play in the process, but I believe that role requires intensive study of a discipline and wide exposure with guidance to works in Japanese. For the concrete process of translating, I think we should train more Americans and other English-speaking people.

Before I develop any further ideas on what ought to be done, let me say briefly why I think social science translation is a losing proposition. I do not know whether the association is with myself, or my work, but I keep coming back to the idea of a tor-

toise. Like the translation I have described, what could be less like a machine than a tortoise? Plodding, inefficient, almost primitive in its method of operation, it is bound to lose the race. At the same time stubborn, determined, perhaps myopic, and determined to finish, it may even win if the competition makes a mistake. For the near future, at any rate, I must face the fact that I am in a losing game.

The organization I represent is small but it is one of the best translating firms in Tokyo. We started out as the publisher and editor of the *Journal of Social and Political Ideas in Japan*, and then founded *The Japan Interpreter*. We incorporated about seven years ago as a joint stock company specializing in social science translation. I am also associated with the Translation Service Center (TSC) in Tokyo as its senior managing editor. That center is administered by the Asia Foundation, with financial support from the Japan-U.S. Friendship Commission. I am also on the editorial staff of a UNESCO publication called *Crosscurrents*.

Our staff consists of four Americans and five Japanese. We do a wide variety of work, particularly in translating and editing. We also write speeches for political and business leaders, act as consultants, and carry out research projects, in addition to publishing our own journal! Our major clients include the Japan Foundation, *Reader's Digest*, the Ministry of Education, University of Tokyo Press, United Nations University, Kodansha publishing house, the Sōkka Gakkai and its political party, the Kōmeito, numerous research institutes, and individual scholars. None of us is particularly brilliant or talented. Perhaps the only difference between us and similar organizations in Tokyo is that we care about the quality of our product. We take pride in our work and all of us are willing to spend the time, no matter how long, to make certain that it is good. As I said earlier, one translation contains the labor of four to six people before it gets sent out for final approval by the client or author.

I have also been told that I am a past master in the way I approach work — a "master," that is, in the sense of lavishing care on the most miniscule detail. This came from a close associate and he meant it as a half-compliment. The flip side of his comment was the message that I am uneconomical in the way I use time and, by modern business standards, that is akin to criminal. Our extravagant use of time is one notorious characteristic of our entire office, I am afraid, and it stems from our setting a high priority on quality. We do not usually undertake work in fields that are unfamiliar to us, but even when we feel confident of our knowledge in a given area, we often ask our translators to do preliminary research. If the paper is on an incident in the Taishō period (1912–1925), we ask them to read as much as they can on the history of those years before they begin. Then we spend more time discussing different points of view and possible interpretations of an unclear passage. We are lavish with time and, unfortunately, we do not have the time to spend so freely. Our dilemma lies in the conflict between quality and quantity. We must continue our profit-making activities to keep the journal going, but we cannot slight the quality of that work and expect the reputation of the journal to remain intact.

Other problems abound, and although money is not the only one, it is related to many of them. First is the lack of genuinely qualified potential or experienced translators. Often very talented people find that translating is simply not rewarding enough, and we lose them to other activities. Of those who do try to stick it out, the number who can write naturally and well is, unfortunately, not large. An ambitious young person is also not likely to tolerate the drudgery of a job that is so often underpaid. Clients, knowing nothing of the tortoise mentality, treat the translator like a very simple machine which can be browbeaten into action. The translator and the printer are lumped together in ignominy at the end of a long process, often to shoulder the blame for faults introduced elsewhere along the line, and are forced to relinquish all praise for the finished product to the author. It is a rare delight to come across that one-in-a-million client or author who sympathizes with the kind of effort the translator has had to invest, not to speak of the constant, relentless pressure he has endured.

It may be that Japanese consumers, with their tendency to value and pay more for hardware than software, cannot be expected to appreciate the inputs into translation. They are willing to pay for volume, but are appalled, for example, when a single-page letter that took an inordinate amount of time to translate costs them a hundred dollars. In general, translators receive more complaints than praise. Not infrequently I have found that only when a third party — especially a foreigner — commends the result does the client or author concede that our work was worth it and ask us to do more. But sometimes we literally get hamstrung and simply cannot proceed. This happens when an author discovers that the translation is not word for word and demands that we redo it in that garbled language called "translationese." Oddly, those who most frequently complain that we have not reproduced the original wording are Japanese who have been educated in the

United States and whose knowledge of English is less than perfect. Time and time again we have had to educate our customers. Sometimes it has taken years, but it has generally paid off and we have won some loyal supporters in the process.

I have come this far, and now I want to try to discover whether it would be possible to set up a large-scale translation service center and press, located in Tokyo and funded mainly by the Japanese government. I propose enlisting the full-time services of ten to twenty native speakers of English and an equivalent number of Japanese, in addition to adequate secretarial staff. (Whether or not the native speakers should all be Americans or of mixed nationalities is a question I have not resolved. I have found that even two Americans fight over commas.) Together these people would undertake the translation and editing of important scholarly books and articles. The center would also function as a translation training ground for both Japanese and non-Japanese, and it would be authorized to issue certificates in recognition of achievement. It would sponsor seminars in the practice and theory of translation, during which trainees would also be guided in the research and reference materials of their discipline. Apart from its regular work, upon request the center would handle the translation and editing of papers by Japanese scholars for international conferences and other materials for publication in English. These services would be provided at a reasonable fee, perhaps 2,000 yen (about 10 dollars) per page of Japanese manuscript, which is less than half what we charge now.

Staff members would be compensated for the time and effort they put in, which would mean reasonable salaries. This would also mean more time for research and discussion, and a tension-free home leave for foreign staff, who need periodic exposure to their own language. There is a lot of translating being done now in Japan, but these efforts are scattered and uncoordinated. Only such a center as the one I propose will make it possible for Japan to send a steady flow of valuable scholarly work, research, and ideas into the world. And only then will people in other countries be able to share in the intellectual environment of Japan, creating a current that flows both ways. The germ of this idea already exists in the Translation Service Center and *The Japan Interpreter.*

The kind of organization I propose is not going to appear overnight. But language remains before us as a looming barrier in a world which cannot afford poor communication, and I think translators, like consumers, owe it to their societies to press for a fairer deal so they can in turn give more. Let me end by quoting from something called "Manifesto" that appeared in the May 1963 issue of the periodical *Translation.* The initials at the end are R. P., which I assume are those of Robert Payne, of the P.E.N. American Center Committee on Translation.

> The translator is the lost child of literature. His name is usually forgotten, he is grotesquely underpaid by the publishers, and his services, however skillfully rendered, are regarded with the slightly patronizing and pitying respect formerly reserved for junior housemaids.
>
> Yet we live by translations, and the translator is the unacknowledged vehicle by which the civilizations are brought together.
>
> The time has come for translators to come out in the open and throw away their badge of servility. Good translations must be fostered, cultivated, and rewarded. The honor of the translator should not go unhonored. We need schools to teach translation. We need to bring translators from abroad to learn the problems of translation in this country. Above all, we need to acknowledge the infinite benefits which come from the translator, and which can come from no one else.
>
> R. P.

I regret that, particularly in Japan, we are no closer now to fulfilling this manifesto than we were twenty-one years ago. When we look at the other changes in our lives that have occurred in those years, it is almost appalling that the situation of the translator has changed so little.

However, it is precisely at such meetings as this that we in this field can share our experiences, grievances and dreams, and move, albeit with the steady determination of a tortoise, toward establishing this field of endeavor as a recognized profession.

LANGUAGE AS MEANING

Japanese and the Challenge of the Future

During the symposium "Calligraphy and the Japanese Word," attention was given not only to the possibilities in the artistic realm that the written language of Japanese can provide, but to the challenges Japanese poses for contemporary technology as well. Rapid and accurate electronic means to reproduce and transmit written Japanese have been achieved in recent years. Such technology has already been put to good use in this country, notably in the library world, where a practical means has now been found, making use of the traditional concept of the written strokes that go to make up each character, to achieve an electronic transmission which permits a level of national bibliographic control scarcely to be imagined even a decade ago. The newest of such techniques is now available to assist the practical functioning in contemporary society of this ancient and complex language.

THE JAPANESE WORD AND THE FUTURE
by John W. Haeger

John Haeger, Vice-president for Programs and Planning at the Research Libraries Group in Stanford, California, has been instrumental in the development of a computerized library system for East Asian materials. Dr. Haeger completed his graduate studies at the University of California at Berkeley, was Chairman of the Department of Chinese at Pomona College from 1968 to 1973, and has done work as well for the Asia Foundation. He is the editor of *Crisis and Prosperity in Sung China* (University of Arizona Press, 1975).

Dr. Haeger's essay discusses the role of the computer in the transmission of language, with a special emphasis on Japanese and the possible future developments to increase speed, practicality, and sophistication.

"To the summit." Takehisa Yumeji, 1910.

Fifteen or so years ago, when I was still a more or less respectable academic, teaching Chinese language and history in southern California, I had my first direct, personal contact with computers. I suppose they had affected me invisibly in all sorts of ways before that, but never mind. A senior student wished to do an honors project on computer translation of Chinese. The project was not notably successful. At the end of the year, the computer had been taught how to translate exactly one sentence of Chinese. It was helpless with all other sentences. But one presumes that the student learned from the experience, and it certainly was the beginning of something new for me.

Since then, of course, the computer revolution has descended upon all of us. We have seen its hallmarks — bookstores with software departments as large as their hardcover textbook departments; neighborhood computer shops with neologistic names; automated teller machines; instant confirmed reservations for almost anything; direct access to the airline guide, reservations computers, and the New York Stock Exchange; and, of course, personal computers in nearly everyone's garage, study, and library. Taking stock of all this, it is probably important to remind ourselves that this so-called revolution is really just the second phase of a much larger change.

The first phase occurred backstage, if you will, for most of us in the humanities and social sciences. On university campuses it was confined to departments of mathematics and electrical engineering and to computer centers where very large, noisy machines chewed through decks of punched cards and performed arithmetic calculations at superhuman speeds.

The salient characteristic of the second phase is that it belongs overwhelmingly to the soft sciences. It is much more concerned with information processing than computation. The contemporary computer's ability to handle natural language with limited user intervention has made the second-phase revolution possible. The vast majority of computing today is informational computing, not large, numerical manipulations.

I think it is worthwhile to observe, too, how fundamentally conservative this is. Most people who interact with computers today are using prerevolutionary skill sets: natural languages, typewriting, and a relatively few commands (mostly plain English words) designed to invoke software that has been written by someone else. We have not spawned a huge generation of programmers; in fact we may soon face a shortage of programmers. Instead, we talk a great deal about "user-friendly" interfaces and simple, menu-driven command languages.

A few years ago, computer literacy was a well-worn phrase. You may remember when colleges debated whether foreign language requirements could be satisfied with a computer language, and when rhetoric about the fundamental importance of computers to a literate person filled the air. Today's definition of computer literacy involves little if any knowledge of a computer language. It is immensely easier than learning French, much less Japanese. It means knowing how to think algorithmically (really only a minor variation on thinking logically) and knowing how to interact with the technical people who write the kinds of software that "soft" scientists need, use, adapt, and modify.

Computer output, too, is less and less recognizable as such. Character fonts designed for the convenience of optical scanners have been superseded largely by conventional fonts and a generation of sophisticated scanning devices which have learned to read them. It is very difficult now to differentiate between a letter created by a word processor and one created by an ordinary typewriter. We are still limited to dot matrices to display text on a video terminal, but font control is available on some devices, graphics capabilities are extensive, and hard copy from modern computer printers has been almost completely conventionalized. Computer-driven typesetting machines can shift fonts with a single keystroke. In fact, software has now been developed which is capable of translating from one type font to another algorithmically. Bodoni Bold can be changed into Times Roman and its point size altered, without storing multiple character sets in memory, by invoking software which describes to the computer how it should manipulate serifs and typeface shapes. Our second-phase revolution is conservative in the sense that, from the user's point of view, we are able to make computer output look more and more like the sorts of things we are used to seeing.

Now, let me turn for a moment to Asian languages and particularly, of course, those Asian languages that are written with the script which evolved in China and its lineal descendants. The story of the computer revolution in East Asia is substantially identical to our own: same phases, same spread. But it began a few years later and it is still a good deal less complete. The *New York Times*, on the front page of its business section, recently ran an article on com-

puter sales in Japan, observing inter alia that, although the sale of word processors in Japan doubled between 1982 and 1983, sales had yet to hit the 100,000 unit mark in any single year. Contrasted with the multibillion-dollar industry we have in this country, and considering the size of the potential market, it is clear that the Asian revolution has far from peaked.

There are probably several socioeconomic reasons for this tardiness, but I will skip them to focus on one basic reason: there is no alphabet in East Asian orthographies. There is therefore, no *qwerty* keyboard; no typewriting in the basic skills sets of the population; and therefore, no natural input device for the computer. The dimensions of this problem range widely. In environments and applications where the necessary character set is relatively small, confined perhaps to a few hundred or a very few thousand characters, the absence of an alphabet can be circumvented in a variety of ways. It is also a less serious problem in the Japanese and Korean environments (where there are alternate phonetic symbol sets) than it is in China, where there is no alternative save romanization, which is really no alternative at all.

By and large, therefore, the second-phase computer revolution in East Asia has, hinged on the development of alternative input devices— alternatives, that is, to the typewriter keyboard. The very first approaches were arbitrary coding schemes. These predate the computer revolution; in fact, they go back to the telecommunications revolution at the end of the nineteenth and the beginning of the twentieth century. Chinese Telegraphic Code is an example. Then there were and are a large number of transliteration schemes in which some form of phonetic representation is used to input characters. Romanization is used in some cases; *kana* in others. These schemes break down into menu-driven systems in which all of the various possibilities, once some sort of phonetic representation has been entered, are displayed on the screen and the operator is expected to make a selection; and complex, sophisticated dictionary look-ups where the machine examines the context. A third approach is large keyboard devices. The conventional Chinese or Japanese typewriter was certainly the first large keyboard device, and it has many descendants. Finally, and more recently, several "character decomposition schemes" have been introduced, of which the RLG/CJK system is one illustration. Some decomposition schemes utilize embedded real-time character generators, meaning that their internal software manipulates as the dot matrices for *components* algorith-

mically in order to create new dot matrices for whole characters. Like the font manipulation software I described earlier, this software knows how to enlarge, reduce, and rearrange. Approaches without embedded character generators, such as the RLG/CJK system depend on dictionary look-ups. The computer stores a dot matrix and an address for each and every character in its "vocabulary" — for RLG/CJK that is between 13,000 and 14,000. The user defines a character with a string of components — *parts* of characters engraved on key tops — and the machine fetches the character and code uniquely associated with that string. This system, admittedly, is not ideal. The alternatives, however, are not much better. It is for this reason that the computer revolution in East Asia is still seriously incomplete. The era of the literate, nontechnical user has, in effect, scarcely begun.

I was told early in my professional education that historians ought, in general, to avoid prediction. Should a stab at prediction become absolutely unavoidable, then the historian should couch his prediction in terms of a decade or more. That way, if he is wrong, he can hope that everyone will have forgotten. On the other hand, should he turn out right, he can always remind a forgetful audience and build a reputation for clairvoyance. But the half-life of computer hardware and software is so short that the recommended ten-year time frame presents problems of its own. So much can change so quickly that predictions are but markings in the sands of time. I believe many refinements are possible on the various alternative input strategies I have described. I have no doubt that they will be made, sold, and used. But — and here is my stab at prediction — one of two other directions will, I suspect, be taken in the future.

One is that standard *qwerty* keyboards of the kind we are used to seeing on typewriters will be phonetically driven and combined with increasingly sophisticated dictionaries. There are already several such systems in commercial production and they are very clever indeed. If that kind of sophistication grows further, it could capture a good share of the market for general purpose text processing in, for example, office automation environments. Such strategies are, however, ill suited to applications which must be precise about the variant forms of characters. They have little promise in the arena of library automation, for example.

A second possibility is real-time, handwritten input. One has to admit that the languages of East Asia are not well adapted to keyboards. The fit is terrible. Several vendors are now experimenting with the use

of an XY tablet on which the user simply writes with a ballpoint pen, pencil, or stylus (brushes do not work very well) exactly as if he were writing on a piece of paper. The software is taught to recognize the number, sequence, shape, pattern, and arrangement of the strokes with such sophistication that it "knows" what character is desired. Software recalls the character from memory or it constructs it algorithmically from the information written on the tablet. If the remaining problems can be solved, I suspect we will see a very large share of the market for word processors in East Asia going toward systems built around this strategy.

It is striking that handwritten input is also a potential solution to two other problems common to the East Asian and Western environments. The first of these involves what we do for the user, Eastern or Western, who cannot type. I mean *really* cannot type at all. There are a lot of certifiable nontypists in the world. Those of us coming out of university environments who had to learn how to type our own papers in order to get through school are not too familiar with the extent of this problem, but in business and industry, nontypists outnumber typists by a substantial margin. Manufacturers of personal computers, recognizing that many users will be more comfortable with a nonkeyboard device to manipulate if not to create text, have begun to market products incorporating keyboard surrogates for some operations. Real-time handwritten input is a logical extension to these surrogates.

The other common problem is the conversion of existing data into machine-readable form. Until a few years ago, the entire record of human experience on this planet was drawn, handwritten, typed or printed. For many reasons, librarians, scholars, and information managers would like to convert portions of this record into machine-readable form. Indeed, the Library of Congress has sponsored a large project to convert old bibliographic data. Even in a Roman alphabet environment, the prospect of keyboarding old data is staggering. When the orthograhic system is ill suited to keyboards, the problem looks even worse. The most promising alternative to keyboarding is optical character recognition, already embedded in several commercial products. You will appreciate immediately that optical character recognition is closely related to real-time handwritten input. Pattern recognition underpins both. What we may therefore see is an integration of the last phase of the computer revolution in the West and the first phase of the revolution in East Asia.

Let me suggest in conclusion that new strategies and technologies for data input will almost certainly imitate prerevolutionary skill sets. I do not expect people to learn very many new skills. New technologies for output will imitate design parameters that have been defined in other environments. I think we will not see the computer giving rise to any new style of writing, composed of dots as if it were some kind of impressionist painting. What we will see is computer technology imitating more and more the things with which our eyes are already comfortable. I also suspect that computer technology will overcome, by consistency and machine coding, the problem of variant character forms which has always plagued conventional information retrieval in East Asia, and compensate with on-line retrieval for the absence, in East Asia, of a natural sorting sequence for data like our alphabet. In both hemispheres, I think, we are likely to remain masters of the machine. I hope this vision is comforting.

One of sixty separate volumes of the early block-printed edition of The Tale of Genji, *published in Kyoto, Japan, in 1654. Japanese Section, Asian Division, Library of Congress.*

A NOTE ON THE JAPANESE COLLECTIONS AT THE LIBRARY OF CONGRESS

 The Library's comprehensive collection of more than 650,000 volumes in the Japanese language represents the preeminent research resource on Japan outside of that country itself.

The collections began modestly in 1875, when the Japanese government accepted a proposal made by the Smithsonian Institution for an exchange of government publications, to be housed in the Library of Congress. The collection grew slowly in its early years, as there were no specialists with either the linguistic or intellectual background necessary to make recommendations for the purchase of Japanese books. The main source of material therefore remained gifts and exchanges. Early major acquisitions included the Crosby Stuart Noyes collection of Japanese art, presented to the Library in 1905, which included 658 illustrated books representing works produced from the mid-eighteenth century to the late nineteenth century. A year later, over nine thousand volumes were selected for the collection by Prof. Kan'ichi Asakawa of Yale University while on a research trip to Japan. The collection was largely dormant, however, until 1930, when the first area specialist on Japan was appointed, and regular acquisition and cataloging programs were initiated. In 1938, the Japanese Section was established as a part of the Orientalia Division, since 1978 designated as the Asian Division.

Collections of Japanese-language material at the Library of Congress increased dramatically soon after World War II, when nearly three hundred thousand volumes of research resource material were added. Holdings were augmented as well by the addition of a wide range of commercially published research materials, systematically acquired by purchase, by exchange — comprehensive sets of Japanese government publications — as well as by gift from numerous individuals, societies, and institutions.

The collections cover virtually all subjects of value to scholarship, with special strengths in the humanities, social sciences, and periodical holdings. Among the unique resources available are printed books and manuscripts that predate the reign of the Emperor Meiji (1869–1912), numbering approximately 4,200 titles in some 14,200 fascicles.

Other unique research materials include prewar Japanese studies of such areas as Korea, Taiwan, Manchuria, China, and the Pacific Islands, as well as microfilms of archival materials from the Japanese Foreign Office from 1868 to 1945. Periodical holdings include approximately ten thousand scientific and cultural titles. Microfilm holdings now exceed five thousand reels. Separate catalogs of Japanese books and serial publications, including the Japanese National Union Catalogue and the Union Card File of Japanese serials, are maintained in the Japanese Section.

Despite the large number of Japanese-language holdings in the Library, some of the most valuable research materials in the collection may be found among those rare items accessioned before World War II. On the occasion of the calligraphy exhibition held in 1984, the staff of the Japanese Section selected a number of important examples from its own rare book collection and exhibited them as a means of suggesting the richness of the Library's holdings.

Hisao Matsumoto
Head, Japanese Section
Asian Division

TRANSLATION BIBLIOGRAPHIES, JOURNALS, AND CENTERS
Prepared By
Key K. Kobayashi and Warren Tsuneishi
With Additions by Philip Nagao

 This is a preliminary attempt to identify existing sources of information on Japanese-to-English translations. We have concentrated on (a) general and special bibliographies in which translations of Japanese works into Western languages (primarily into English) are listed; (b) translation journals or general periodicals which carry a substantial number of translations; and (c) centers and clearinghouses providing information on translations.

Despite the fact that our focus is on the United States, we have also included information on Japanese sources.

A. Translation Bibliographies

The bibliographical control of translations from the Japanese into Western languages appears to be quite good, though the information needed must be sought in a variety of general and special sources, and oftentimes information is not available on current or recent translations. Science and technology appear to be the best covered through national and international clearinghouses and their organs. Improvement is needed in the humanities and social sciences.

General Bibliographies

1. Index translationum. Repertoire international des traductions. International bibliography of translations. Paris: International Institute of Intellectual Cooperation, 1932–40, no. 1–31. New Series, v. 1– , 1948– . Paris: UNESCO
 Note: The volume for 1975 published in 1979 "is a bibliographic catalogue of 47,232 translated books published in 1975 in 67 Member States . . . arranged by countries . . . under the 10 major headings of the Universal Decimal Classification . . . volume . . ." Japanese language works translated into English are difficult to identify since this is a country-by-country listing of published translations, e.g., most of the hundreds of listings under "Japan" are Western-language

books translated *into Japanese*. One must search under appropriate headings (e.g., Literature) under U.S. and Great Britain for English-language translations of Japanese fiction. Alternatively, one must search in the author index for probable authors (e.g., Mishima, Kawabata) whose works may have been translated during the preceding year.

2. Translation register-index. v. 1, no. 1– ; 1967– . Chicago: National Translations Center, John Crerar Library of the University of Chicago. Monthly, with semiannual and annual cumulated indexes.
 "The Center is a depository and information source for unpublished translations into English from the world literature of the natural, physical, medical and social sciences. . . . A cooperative nonprofit enterprise, its services help (a) to eliminate costly duplication of translation effort . . .; (b) to disseminate information on available translations, and (c) provide copies of translations" — General Information Leaflet.
 Includes under "Human and Social Sciences" the following: Administration and management; Documentation and information technology; Economics; History, law, and political science; Human factors engineering; Humanities; Linguistics; Man-machine relations; Personnel selection, training, and evaluation; Psychology (individual and group behavior); and Sociology.

3. World transindex (replacing World index of scientific translations and list of translations notified to the International Translations Centre). 1960– . Monthly. Delft, Netherlands: International Translations Centre. The Annual Index consists of a cumulation of the Source and Author index and is published separately.
 "The International Translations Centre serves as a clearinghouse for scientific and technical translations prepared throughout the world from East European and Asiatic languages into Western languages, mainly English, French and German." — Preface.
 Note: Indexes primarily scientific and technical books and journals, but includes a section on "Behavioral and social sciences."

4. Yearbook of comparative and general literature. v. 1– ; 1952– . Bloomington, Indiana: Indiana University. Annual
 Includes list of English translations from other languages.

Special Bibliographies

5. Bibliography of Asian Studies, 1941– . Ann Arbor: Association for Asian Studies [formerly Far Eastern bibliography].

> Annual bibliography of works in Western languages, which includes translations in section on Japan.

6. Fujino Yukio, comp. Modern Japanese literature in western translations; a bibliography. Tokyo: International House of Japan Library, 1972. 190 p.

> ". . . comprises a listing . . . of translations into Western languages of Japanese fiction, poetry, drama, and other prose writings from 1868 to the present . . ." — Preface.

7. Yoshizaki Yasuhiro, comp. Studies in Japanese literature and language; a bibliography of English materials. Tokyo: Nichigai Associates, 1979. xxxviii, 451 p.

> "This bibliography covers most of the studies in Japanese literature and language that have ever been published in the English language. Its main part consists of the criticism of Japanese literature and academic studies of the Japanese language. Other items included here are: general introductions to Japanese culture, English translations of major literary works, Japanese textbooks for English speakers, bibliographies, journals, institutions for Japanese studies outside Japan, and scholars of Japanese language and literature who write in English." — Foreword.

8. Inada Hide Ikehara. Bibliography of translations from the Japanese into western languages, from the 16th century to 1912. Tokyo: Sophia University, 1971. viii, 112 p.

> *Note:* 439 translations of Japanese works into Western languages listed "chronologically and in alphabetical order under the name of the translator, if known . . ." —Introduction. Includes author, translator, original title, and subject indexes.
> "Bibliography": p. 87–91.

9. International House of Japan Library, comp. Modern Japanese literature in translation: a bibliography. Tokyo: Kodansha, 1979. 311 p.

> Revised enlarged edition of item 7, above. ". . . invaluable compendium, including both Asian and European languages, is a listing primarily by author, of translations of Japanese fiction, poetry, drama and other prose writing from 1868 to the present." — Publisher's notice.

10. Japan P.E.N. Club. Japanese literature in European languages: a bibliography. Tokyo: Japan P.E.N. Club, 1961. xii, 98 p. Supplement, 1964. 8 p.

> "In this bibliography the compilers have tried to list all materials relative to Japanese literature that have been written in European languages and published by the end of 1956
> "The term 'literature' has been interpreted in the broadest possible sense. . . .
> "The outstanding feature of this bibliography is that in listing translations the compilers have made it a rule to show the original Japanese title in both roman letters and Japanese characters.
> "The bibliography is divided into the following five parts:
> 1. General; 2. Classical literature; 3. Classical theater; 4. Modern literature; 5. Juvenile and folk literature."

11. Alfred H. Marks. Guide to Japanese prose. Alfred H. Marks and Barry D. Bort. 2nd ed. Boston: G. K. Hall, 1984. 186 p. (The Asian literature bibliography series).

> *Note:* Annotated guide to translations of Japanese prose writings from the earliest time to the present day. An index of authors, editors, translators, and titles is provided in a single alphabet listing.

12. Leonard Cabell Pronko. Guide to Japanese drama. 2nd ed. Boston: G. K. Hall, 1984. 149 p. (The Asian literature bibliography series).

> *Note:* Annotated guide to translations from *nō*, *kyōgen*, *kabuki*, *bunraku*, and *shingeki* texts, as well as to critical works on Japanese drama. An index of authors, editors, translators, and titles is provided.

13. J. Thomas Rimer. Guide to Japanese poetry. J. Thomas Rimer and Robert E. Morrell. 2nd ed. Boston: G. K. Hall, 1984. 189 p. (The Asian literature bibliography series).

> *Note:* Annotated guide to translations, arranged by topic and chronology, of Japanese poetic literature from the earliest time to the present. An index of authors, editors, translators, and titles is also included.

B. Translation Journals

There exist numerous journals, periodicals, and newspapers which carry occasional translations of Japanese-language works from various genres. Here we have concentrated on identifying those translation journals which carry Japanese-to-English

translations only, or journals whose contents consist substantially of translated materials. The emphasis is also on the humanities and social sciences; for translation journals in science and technology, please see item A. 5 above.

1. Economic eye, a quarterly digest of views from Japan, v. 1– ; September 1980– . Tokyo: Keizai Koho Center (Japan Institute for Social and Economic Affairs).

 "A quarterly publication of the Keizai Koho Center, a private non-profit organization that works in cooperation with Keidanren (Japan Federation of Economic Organizations) to provide information on the Japanese economy. Each issue carries full or partial translations of recent Japanese magazine articles dealing with economic topics believed to be of interest to foreign readers. . . . Full responsibility for the translation of the articles rests with Japan Echo, Inc." Verso of cover of vol. 1 (Sept. 1980).

2. Japan echo. v. 1– ; 1974– . Tokyo: Japan Echo, Inc.

 "*Japan Echo* is a quarterly journal of opinion dedicated to fostering deeper mutual understanding through improved communication. To this end, each issue will carry full or partial translations of important articles by prominent Japan critics and commentators . . . prepared for the Japanese audience and published in leading Japanese publications."

3. The Japan economic journal, international edition of Nihon Keizai Shimbun. v. 1– ; 1963– . Tokyo: Nihon Keizai Shimbun, Inc.

 Includes translations of articles from the Japanese-language edition of *Nihon Keizai Shimbun* and special English-language articles on the Japanese economy for the attention of foreign readers.

4. Japan quarterly. v. 1– ; 1954– . Tokyo: Asahi Shimbun.

 Each issue contains translations of modern literary works (short stories, parts of novels, etc.), translations of articles commenting on the current scene, and a list of translators.

5. Japanese economic studies. v. 1– ; Fall 1972– . Armonk, New York: M. E. Sharpe, Inc. [formerly known as the International Arts and Sciences Press, Inc.].

 "*Japanese Economic Studies* contains translations of economics material from Japanese sources, primarily scholarly journals and books. The selections are intended to reflect developments in the Japanese economy and

to be of interest to those professionals concerned with this field."

6. Japanese literature today. no. 1– ; March 1976– . Tokyo: Japan P.E.N. Club.

 Japanese Literature Today, as a successor to *P.E.N. News* (1959–71) will carry "besides surveys of Japanese literature during the past year and an English translation of a recent work . . . a list of works of Japanese literature recently translated into European languages." — Masthead.

7. Literature East and West. v. 1– ; 1954– . Austin, Texas: Oriental-Western Literary Relations Group, Modern Language Association.

 Includes translations from Japanese literature.

8. Monumenta Nipponica; studies in Japanese culture. v. 1– ; 1938– . Tokyo: Sophia University.

 Each issue contains translations of Japanese classical works: belles lettres, philosophy, religion, history.

9. Translation; the journal of literary translation. v. 1– ; Winter 1973– . New York: The Translation Center. 307 A Mathematics Building, Columbia University, N.Y. 10027.

 "*Translation* is published by the Columbia University School of the Arts under a grant from the Literature Program of the National Endowment for the Arts." — Masthead.

10. Translation review. no. 1– ; Spring 1978– . Richardson, Texas: The University of Texas at Dallas.

 Official publication of the American Literary Translators Association, which will "provide continuously updated articles on copyright problems, listings of reference works, of translations in progress, [and] of journals publishing translations. . . ." — Note in no. 1, Spring 1978.

11. U.S. Embassy, Japan. Daily summary of Japanese press. 1952– . Tokyo.

12. U.S. Embassy. Japan. Summaries of selected Japanese magazines, 1954– . Tokyo.

13. U.S. Foreign Broadcast Information Service. Daily report. Volume IV Asia & Pacific. no. 1– ; January 2, 1968– . Washington, D.C. Superseded Daily report. Far East Volume II, Asia & Pacific, February 6, 1967–December 28, 1967; a title change from Daily report, Far East, November 18, 1955–February 3, 1967.

 "Hundreds of Foreign Broadcast Information Service (FBIS) radio news transmissions, newspaper editorials and articles, and maga-

zine features are monitored daily by expert U.S. analysts. The best of these translations are grouped in eight areas (volumes) of interest . . . radio and press agency coverage of all nations along the western Pacific littoral . . . as well as speeches and reports from [Japan]" — Notice in *National Technical Information Services* pamphlet.

14. The wheel extended; a Toyota quarterly review. b. 1– ; Spring 1971– . Tokyo: Tokyo Motor Sales Co., Ltd.

 "Articles in *The Wheel Extended* are restricted to translations from Japanese"— Editorial Statement. Focuses on articles relating to transportation, urban development, communications, industry, technology.

15. White papers of Japan; annual abstract of official reports and statistics of the Japanese Government 1969/70– . Tokyo: Japan Institute of International Affairs.

 English-language abstracts of selected white papers, e.g., on Agriculture; Defense; Economy; Foreign Policy: International Trade; Local Government Finance: Overseas Economic Cooperation.

Note: The following three journals are of use for reference purposes but are not being published at the present time.

1. Japanese business journal. Dec. 1971–Dec. 1972. Austin, Texas: Ralph McElroy Co., Inc.

 "The *Japanese Business Journal* is published to provide English-speaking businessmen with access to Japanese business literature. Each monthly issue consists of three sections: a feature section, containing complete translations of selected articles; an abstract section; and a listing by subject of the articles published during the previous month in the business literature in Japan." — Masthead.

2. The Japan interpreter; a quarterly journal of social and political ideas. v. 1–13; 1963–1980. Tokyo: Japan Center for International Exchange. Title varies: v. 1–5, 1963–1967: Journal of social and political ideas in Japan.

 Largely comprises translations of selected articles and parts of books.

3. Traditions. v. 1–16; 1976–1981. Tokyo: The East Publications, Inc.

 Traditions, a quarterly journal, issued as a sister publication of *The East* which began in 1964. ". . . complete and abridged translations of the classics of literature, religion, art,

and thought and scholarly treatises in the field of history, sociology, linguistics . . . provide deeper understanding of the Japanese tradition."

C. Translation Centers and Clearinghouses

1. Columbia University. Translation Center. New York, New York 10027.

 This Center, funded by the National Endowment for the Arts, "is offering: Fellowships of $10,000 each to American writers who wish to perfect their knowledge of a lesser known language in order to do literary translation from that language and Translation Awards (generally of $500) to translators who have completed a substantial part of a translation and either have a commitment or a strong expression of interest from a publisher." — Announcement in *Translation.*

2. Foreign Press Center — Japan, 6th Floor, Japan Press Center Building, 2-2-1 Uchisaiwai-cho, Chiyoda-ku, Tokyo, 100, Japan.

 "The Foreign Press Center, a nonprofit foundation, began operations on October 1 [1976], with a starting budget of 240 million yen financed jointly by Government funds . . . donations from private sectors, and membership fees. . . . Its functions . . . distribution of translated copies of Foreign Ministry announcements . . . materials prepared for foreign audiences by other Government ministries and agencies and private organizations. . . ."

3. Japan-United States Friendship Commission. 1875 Connecticut Avenue, N.W., Suite 709, Washington, D.C. 20009.

 Beginning in 1978, an annual "Friendship Fund" prize of $1,000 for the best book-length translation of Japanese literature into English by a first-time American translator will be awarded by the Japan-United States Friendship Commission.

 "The purpose of this prize is to encourage new American translators in the craft of literary translation from the Japanese, and thereby to increase the amount of good Japanese literature available in print for the English-reading public

 "Criteria for consideration are the following: 1. Any work of Japanese literature, of any period, known and published in Japanese, of book-length fiction, literary essays and memoirs, drama or poetry in English translation . . .; 2. An American translator, with no book-length

translation published or widely sold in the United States before January 1, 1978. . . ."

4. John Crerar Library of the University of Chicago. National Translations Center. 5730 South Ellis Avenue, Chicago, Illinois 60637.

"The National Translations Center (NTC) was established by the Special Libraries Association in 1946 and was transferred to the John Crerar Library in 1968. NTC "serves as an international depository for [unpublished] material translated into English from any foreign language

"Translations of material in all fields of theoretical and applied sciences, including medicine . . . [are held by NTC]." — *Encyclopedia of Information Systems and Services.*

5. National Endowment for the Humanities. Translations Program. Division of Research Programs. 806 15th Street, N.W., Washington, D.C. 20506.

"Purpose — The Translations Program provides support for annotated, scholarly translations that contribute to an understanding of the history and intellectual achievements of other cultures and serve as tools for further disciplinary or comparative research. Scope — translations from any language, on any topic relevant to the humanities are eligible. . . ." — Announcement.

6. Translation Service Center, The Asian Foundation, 5-13-4, Shiroganedai, Minato-ku, Tokyo, Japan.

Established in 1978 by the Asian Foundation, with support from the Japan-United States Friendship Commission and other American and Japanese sources. The Center selects representative articles from the Japanese press and magazines, translates them into English, and distributes the translations for publication in American newspapers, general circulation magazines, and scholarly journals.

7. U.S. Joint Publications Research Service (JPRS). JPRS. 1000 N. Glebe Road, Arlington, Virginia 22201.

"Translates and abstracts foreign languages political and technical media for Federal agencies. . . ." — Notice in *National Technical Information Services* pamphlet. Translations covering political, economic, sociological, scientific, and technological developments are available from the National Technical Information Services of the U.S. Department of Commerce, 5825 Port Royal Road, Springfield, Virginia 22161.

8. University of Texas, Dallas. Translation Center. Box 830688, Richardson, Texas 75083-0688.

This Center serves "the needs of translators, publishers, teachers, writers, and students in the contemporary arts and humanities — [and provides] referral service — clearing house — translators, translations in progress — research service — translation library — workshops in the theory and practice of translation." — Announcement in *Translation.*

TECHNICAL TERMS AND HISTORICAL CHART

Standardized translations have been adopted throughout the essays included in this volume when references are made to the various types of calligraphy developed in China and Japan.

ENGLISH	CHINESE	JAPANESE
Seal script	**chüan-shu**	**tensho**
Clerical script	**li-shu**	**reisho**
Standard script	**k'ai-shu**	**kaisho**
Semicursive script	**hsing-shu**	**gyōsho**
Cursive script	**ts'ao-shu**	**sōsho**

HISTORICAL PERIODS IN CHINA AND JAPAN

The various historical periods in both China and Japan which are mentioned in the essays are summarized in this chart.

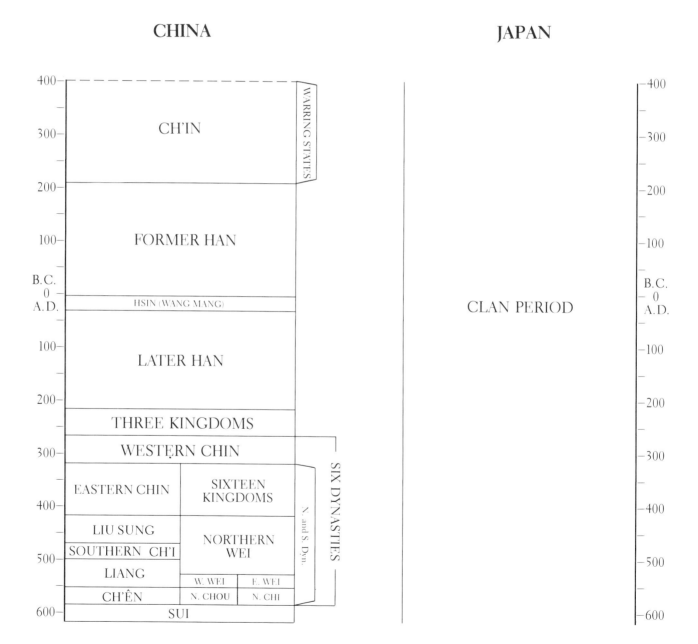

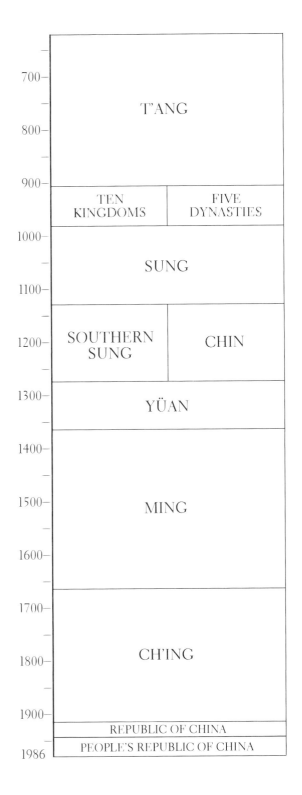

700	
	T'ANG
800	
900	
	TEN KINGDOMS / FIVE DYNASTIES
1000	
	SUNG
1100	
1200	SOUTHERN SUNG / CHIN
1300	YÜAN
1400	
1500	MING
1600	
1700	
1800	CH'ING
1900	
	REPUBLIC OF CHINA
	PEOPLE'S REPUBLIC OF CHINA
1986	

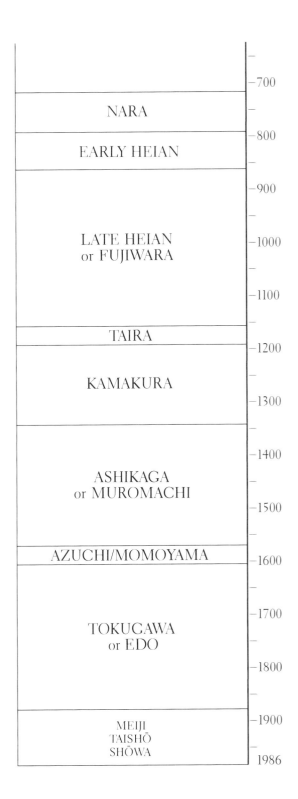

700	
	NARA
800	EARLY HEIAN
900	
1000	LATE HEIAN or FUJIWARA
1100	
	TAIRA
1200	
	KAMAKURA
1300	
1400	
1500	ASHIKAGA or MUROMACHI
1600	AZUCHI/MOMOYAMA
1700	
	TOKUGAWA or EDO
1800	
1900	MEIJI / TAISHŌ / SHŌWA
1986	

1988